AUSTRALIAN
ABORIGINAL
PAINTINGS

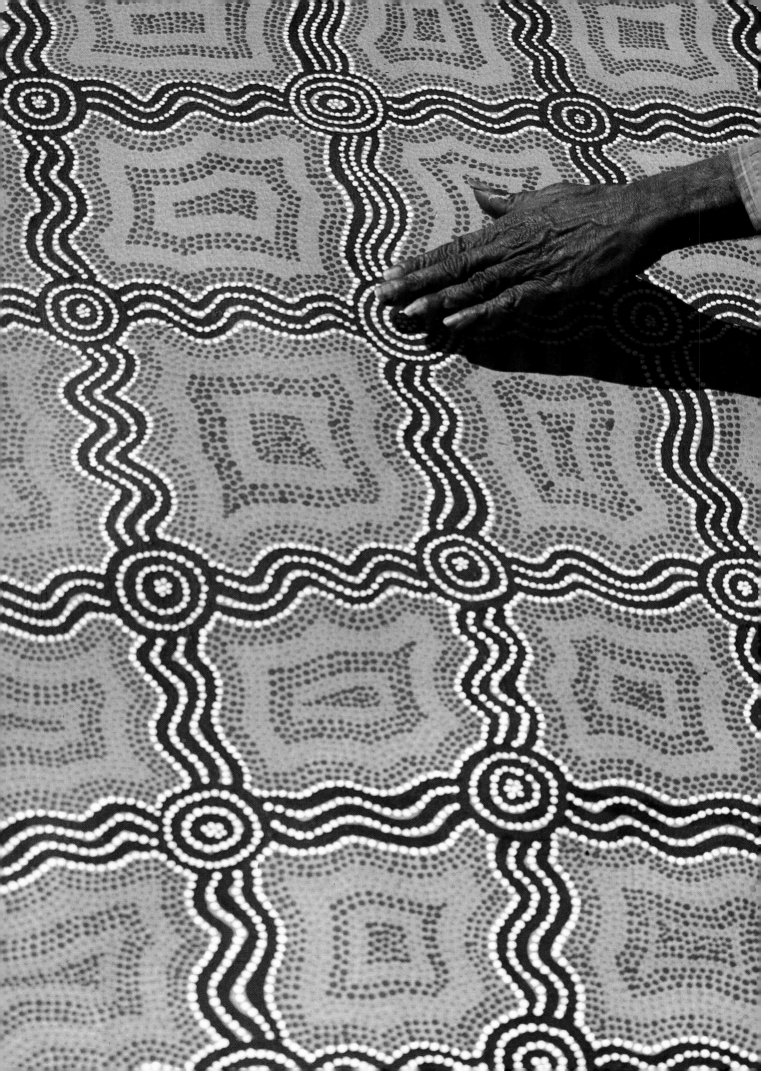

AUSTRALIAN
ABORIGINAL
PAINTINGS

Jennifer Isaacs

Dutton Studio Books New York

PHOTOGRAPHERS

Landscape and Portraits
CLAUDE COIRAULT: Paintings of the Western Desert
REG MORRISON: Bark Paintings of Arnhem Land

Paintings
MARK LENNARD
REG MORRISON
JENNIFER STEELE
HENRY JOLLES
CLAUDE COIRAULT
MICHAEL RILEY
PER ERICSON
ADRIAN HALL

Cover photograph by Mark Lennard

Half Title
Spinifex. Photograph by Claude Coirault.

Title
Women's Dreaming and Tjalapa, by Mick Namarari Tjapaltjarri.
 Photograph by Jennifer Isaacs.

Endpapers
Desert sand. Photograph by Claude Coirault.

DUTTON STUDIO BOOKS

Published by the Penguin Group
Penguin Books USA Inc., 375 Hudson Street,
New York, New York 10014, U.S.A.

Penguin Books Ltd, 27 Wrights Lane,
London W8 5TZ England

Penguin Books Australia Ltd, Ringwood,
Victoria, Australia

Penguin Books Canada Ltd, 2801 John Street,
Markham, Ontario, Canada L3R 1B4

Penguin Books (N.Z.) Ltd, 182-190 Wairau Road,
Auckland 10, New Zealand

Penguin Books Ltd, Registered Offices:
Harmondsworth, Middlesex, England

Originated by Weldon Publishing
a division of Kevin Weldon & Associates Pty Limited,
Sydney, Australia, 1989

First published in the US by Dutton Studio Books, an imprint of Penguin Books USA Inc.

First US printing, February, 1992
10 9 8 7 6 5 4 3 2 1

© Copyright 1989 text: Jennifer Isaacs
© Copyright 1989 design: Kevin Weldon & Associates Pty Limited

Library of Congress
Catalog Card Number: 91-75548

Typeset in Australia by Keyset Phototype, Sydney
Printed and bound in Singapore by Toppan Printing Co. Pty Ltd

ISBN: 0-525-93407-3

CONTENTS

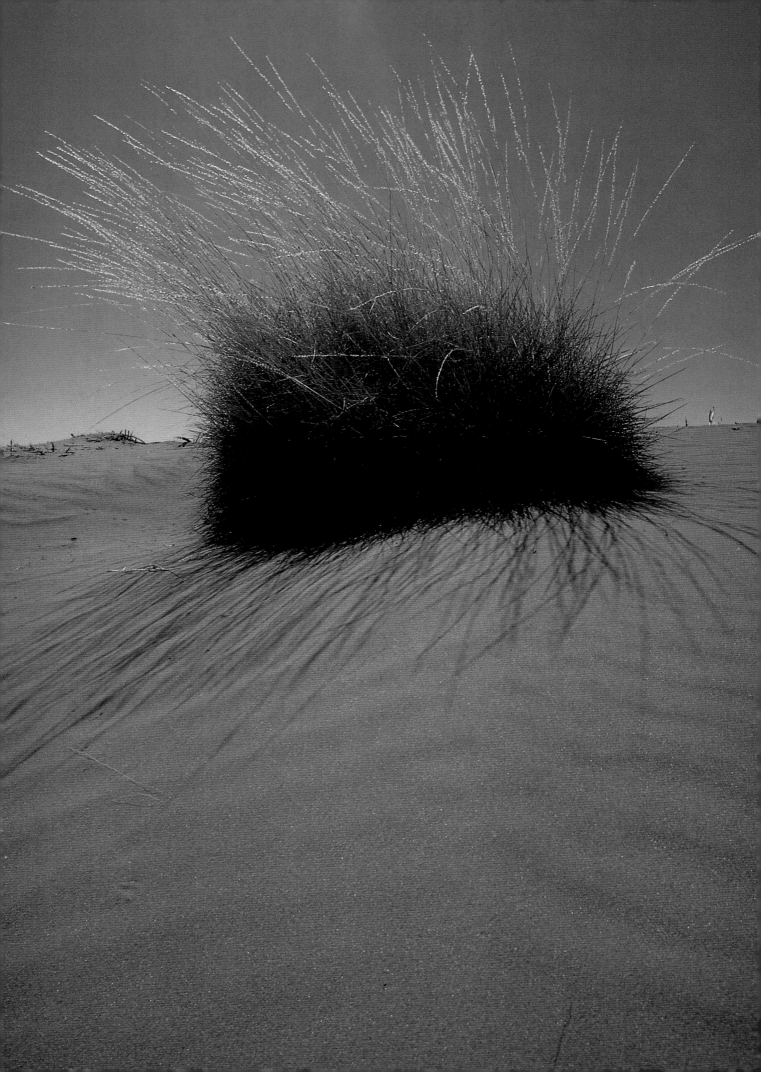

INTRODUCTION

Aboriginal painting has undergone a renaissance over the past two decades as artists express the strength and resilience of their ancient religious values and their deep connection to the Australian landscape itself.

Desert communities have preserved the content of their ceremonial 'sand paintings' in contemporary acrylic works on canvas. Many of these are most beautiful and exciting contemporary designs in which the traditional ochre colours are used alongside vibrant blues, greens and oranges.

In the far north in Arnhem Land, the traditional painters keep to their ancient media of colours from the earth applied to large strips of eucalyptus stringybark. These bark paintings range from huge depictions of myths in episodes across the surface to strong spirit images, rainbow serpents or lyrical flowing designs of animals and plants from the artists' Dreaming.

This book presents an overview of traditional Aboriginal religious paintings. They are all 'from' the Dreaming, the Tjukurrpa, the Wonggar, the Creation, and express this now, in present day Australia.

I have wanted to compile this book for over a decade but it seemed, in publishing terms, the climate was never right. Now it is. Aboriginal art, an ethnographic sideline for so long has exploded into public awareness justly evaluated as a major form of contemporary art with ancient philosophical connections.

This book does not analyse or explain the paintings. The presentation is purposely simplified so that the paintings, with their minimal notes, are left to speak for themselves as much as possible. The tools the reader or viewer has for interpretation are very much those the artists have provided – not 'too much story' – just enough to understand, and begin to appreciate the deeper levels.

Three quarters of the works included are now in private hands. With the co-operation of galleries, they were photographed and documented before sale over the period from 1983 to 1988. Some older works also appear, particularly bark paintings.

This is a collection of religious paintings to contemplate, to admire and to meditate upon. Hopefully, by this suble means, they will bring the reader close to an understanding of the appreciation and love for 'country' which the artists are expressing.

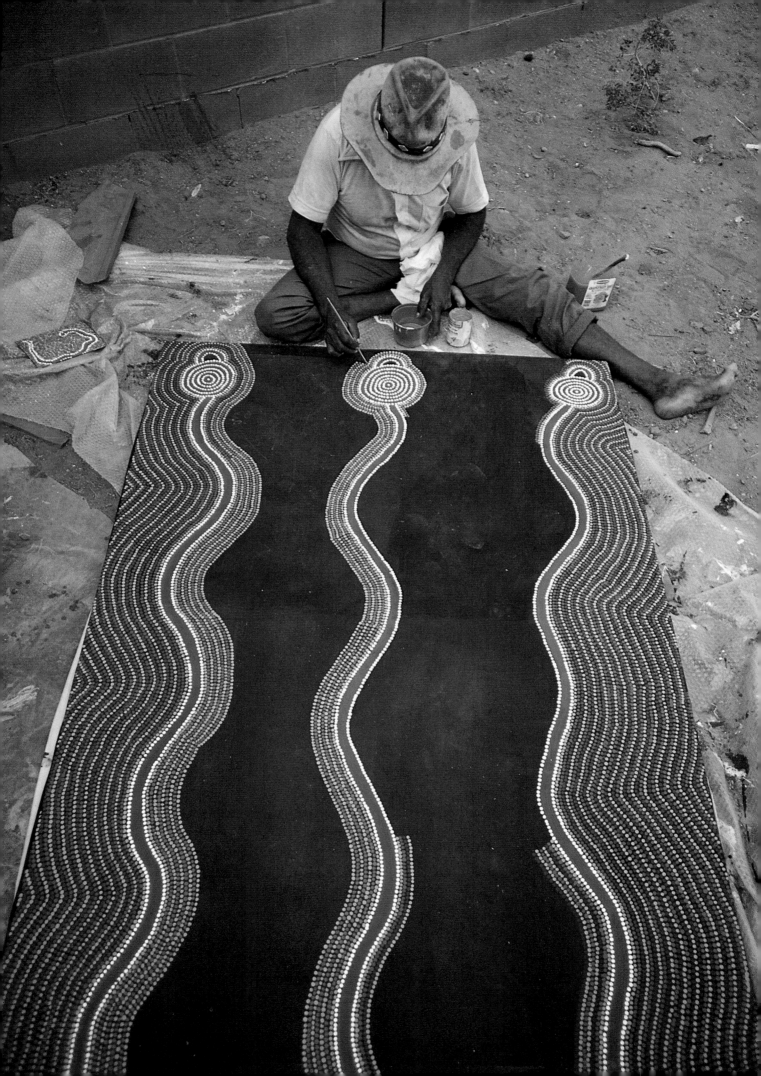

PAINTINGS OF THE WESTERN DESERT

The symbols used to denote meaning in contemporary Aboriginal desert paintings are exactly the same as those found on cave paintings and, more particularly on rock engravings over 10 000 years old. Whether designs are constructed on the ground for ceremony, applied to the body, or painted on canvas or board as part of the contemporary art movement, the religious paintings of desert Aboriginal artists are a direct continuation of this ancient creative symbolic art tradition.

Throughout the millennia Aboriginal people developed an understanding of the cosmology — the natural forces of the earth, the inhabitant flora and fauna, indeed the total cosmos in which man, woman, animals, nature and natural phenomena were all linked. Central to the belief is the Tjukurrpa — a 'creation' time when ancestors in human, animal, plant and insect form engaged in epic struggles. They made features of the landscape such as rivers, hills, waterholes and special rock formations. They gave their descendants, present day Aboriginal people, the symbols, designs and sacred objects which embody the essence of their power and which are used or evoked in song, ceremony and sacred paintings. This Tjukurrpa is with us still. It is evoked in ceremony, where the power of the ancestor takes over the dancers as they mime and therefore become the great ancestors. These ancestors continue to interact with the people and can influence life, death, the seasons and therefore food supplies.

LANDSCAPE AND WATER

The Australian deserts are vast arid areas which stretch from the continent's centre towards the coast of Western Australia, south to the Nullabor Plain and east into New South Wales and Queensland. Survival in the deserts for Aborigines has always depended on a detailed knowledge of waterholes and the behaviour of plant and animal species, a knowledge gained within the family through the ceremonial

Dinny Nolan Tjampitjinpa, a senior artist from Papunya.

teaching of songs and song cycles recording the ancient journeys of the group's ancestors.

Until quite recently the location of water dominated the lives of Aboriginal people and the search for food could not be separated from the need for water. Chains of waterholes or 'soaks' follow the great Dreaming tracks and many paintings record these. They occur in sequences of locations memorised as part of the sacred ceremonial song cycles, and visited by custodians who care for each as sacred sites. From a very young age children memorise songs about the waterholes.

The actual amount of water can vary from large catchments in deep gorges containing thousands of litres of water to small soaks at the foot of rocky outcrops — water hidden beneath rocky overhangs often under the sand itself. Other small water sources are really only a few cupfuls of water left in rock basins or even in the cavities of large old eucalyptus trees.

The traditional Aboriginal pattern of movement in the desert was largely from one water source to the next meeting at various times in larger groups. Knowledge of the botanical environment was immensely detailed and still is; the paintings record all this knowledge. But primarily, the paintings recall the ancestors that created the great rocks and formations; some even map Aboriginal knowledge of subterranean water courses and channels made in the Dreaming by particular ancestors. One story tells of the Witchetty Dreaming. The paths made by the supernatural grubs as they burrowed underneath the ground in the roots of acacias were filled behind with water as they went, and are now underground water channels.

Natural forces like winds, floods and fire are also features of the mythology, and are the result of ancestral behaviour. Phenomena like prodigious or unusual winds, floods or bush fires are always attributed to the activity of ancestral beings. Some paintings concern willy-willy winds — these are sometimes quite ferocious in the desert and great ones of the past are remembered as having caused significant destruction. Similarly, the appearance and disappearance of water on clay pans is recorded in Dreaming stories and often attributed to the activity of Rainbow Serpents or Snake ancestors.

Many paintings relate to water. One particular design, frequently used by Kintore painters of the Pintubi group, records the story of the Water Dreaming at Tjikarri, west of Kintore in Western Australia, near Sandy Blight Junction. These designs frequently depict two waterholes distanced from each other yet linked with a trio of meandering lines. The mythology indicates that there are three underground streams and, according to dowser bushmen of the desert — both Aboriginal and white — these streams do exist near the sites depicted.

The Dreaming story relates that once the site of Tjikarri was very verdant. An old man, the owner of the site, lived there. When a distant group of men travelled from the west and asked for water they were refused. But they crept to the waterhole in the night and stole the water in a string bag made from human hair. The water keeper woke and chased them, throwing his boomerang at one thief. After this the thieves divided into two groups. They continued to travel across the country carrying the stolen water. The lines of their journey and interactions at each encounter are marked by many sites; the lines of the waterholes can also be seen on

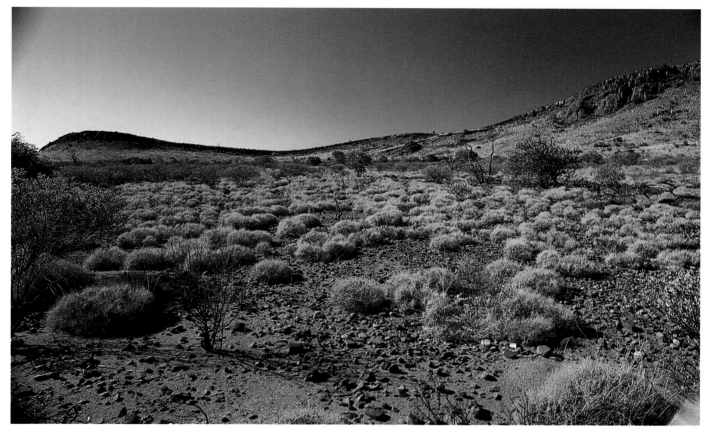

Dotted spinifex vegetation north of Alice Springs.

maps made by hydrologists and extensively in the elaborate paintings by Clifford Possum Tjapaltjarri.[1] There are many important individual dreamings commemorating particular animals and plants: witchetty grubs, snakes, ants, goannas, particular sugar bushes (trees which, due to insect activity, exude a type of sugary substance that people enjoy eating on bushwalks) and small marsupials.

THE ANCESTRAL DREAMING

Each great desert rocky range or tor from Uluru to Katatjuta, throughout the Musgrave, Mann and Tomkinson Ranges, or north of Alice Springs throughout the Hermansberg area, or the Macdonnel Ranges through to Central Mt. Wedge and so on, have origins in Aboriginal religion which are recorded in the art. Papunya, the place where the contemporary desert acrylic painting movement began, is the home of the honey ants and it is logical that this subject forms the basis of many paintings from that area.

Throughout all the 'stories' the nature of the ancestral beings and their activities is closely understood and given parallels in the natural phenomena resulting from their activity. Each 'story' gives information not only about the great religious creative facts of the landscape, but also essential survival knowledge.

11

THE TINGARI

One of the central themes of the great early paintings from the Papunya school is the Tingari cycle.

The events that surround the journeys of the Tingari are essentially secret and sacred to the Pintubi people. Generally the artists will reveal little about the Tingari in relation to the paintings. They are ancestors of the Tjukurrpa, the Dreaming, who travelled over vast stretches of the country performing rituals and creating and shaping particular sites. They were usually followed by Tingari women and accompanied by young novices whom they trained during ceremonies performed along the way. Their travels are enshrined in song cycles and the mythology about them forms a central part of teaching during the initiation ceremonies of youths. In common with the Dreaming ancestors of the far north, the law as taught by the Tingari provides many explanations for contemporary customs which relate to animals, the environment and the relationship between men and women.

The 'classic', if that term can be used, design which symbolises the Tingari mythology is a series of roundels in rows of three. This deeply sacred configuration was almost exclusively used throughout the 1970s to denote the Tingari cycle, however, recent paintings in the 1980s have extended or otherwise embellished this sequence.

WOMEN'S DESIGNS

Women have important religious status as well as men. They own tracts of land through their own Dreamings and operate parallel but interconnected religious lives with the men. It is common for women to begin sacred men's ceremonies, their camp set aside a little from the main activities. Groups of related women will sit together as dusk draws close and sing cycle after cycle of sacred songs, each one drawing the ancestors closer as they retell the extremely ancient cycle of journeys. From time to time lines of women will rise and re-enact those journeys, dancing and moving their feet through the sand. The path left behind by the feet of the dancers in the desert sands forms another kind of symbolic art, the 'tracks' of the Tjukurrpa.

During women's ceremonies the participants paint their breasts, shoulders and upper arms with patterns and designs appropriate for the Dreaming of the ceremony. Two different sub-sections are always present in these ceremonies: the participants and the guardians — the relations whose job is to ensure 'correctness'.

As well, women have their own ground designs, particularly in the Warlpiri area west of Papunya around Yuendemu and recently a large sacred ground design was constructed and then enshrined in a local museum at Mt. Allan. Sacred emblems in the form of poles are erected in the centre of the design and these are also covered with plant down and ochre in traditional patterns.

Women's sacred dreamings most often tell the story of the journeys of female ancestors. One records two sisters who travelled from Pintupi country right down into Pitjantjatjara land where they became the most frequent subjects painted by Pitjantjatjara women artists. Another story relates to seven sisters who were pursued by a single man and this sacred cycle has its climax in the return of these

ancestors to the sky from whence they had come, where they can still be seen today as Orion and the Pleides.

VEGETATION

The information in all paintings about the ancestral journeys is allied to a great deal of knowledge related to survival in the desert. When the ancestral men and women moved across the dunes and spinifex plains to form the rock ridges and waterholes, they gathered and thereby marked out 'bush tucker' areas. Desert vegetation grows naturally in clumps or zonal areas, changing drastically from sand dune to plain to river bed or rocky outcrop. Desert artists' eyes are finely attuned to the soft changes in colour, shape and linear form of Australian native plants as this is essential in the search for bush food, and the paintings themselves actually reflect the natural change in vegetation patterns and hues over the artists' tribal country. It is possible to discern, for example, soft grey mulga areas where seeds ripen and can be ground into edible paste; 'witchetty' bush areas of acacia where the thick white grubs must be dug from the roots before they metamorphose and fly away as moths, and purple flowering plains and salt pans where the fruits of non-toxic desert solanums, 'bush tomatoes', are carefully chosen to eat, grind up or store like raisins.

MAPS AND SYMBOLS OF COUNTRY

In many paintings artists seem to have an eerie sense of aerial knowledge and although many now travel by plane, in the early days this was certainly not the case and the paintings have changed little in their ability to interpret vast areas of the desert landscape accurately as though from above. This suspension over the

Desert tors, waterholes or rock formations are the physical evidence of ancient Dreaming events.

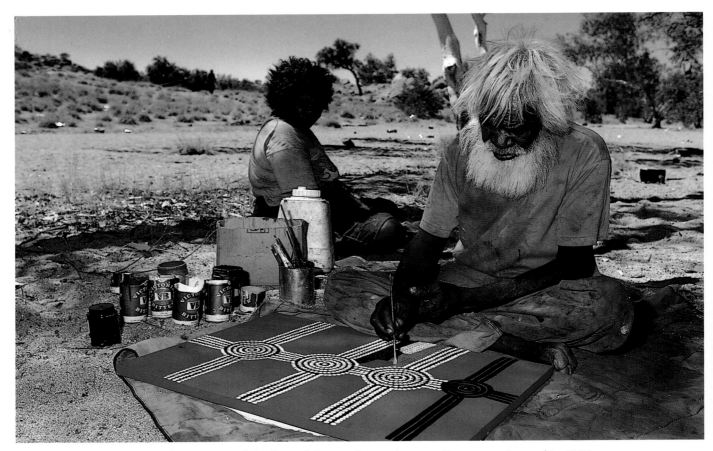

Billy Stockman, one of the first of the modern painters at Papunya, pictured in 1988.

landscape, so evident in Aboriginal desert work, has inspired many film makers to attempt to recreate the journeys from the air in either helicopter or small plane, tracing ancestral paths from desert tor to desert tor or from ridge to ridge. But the sacred sites are not always major landforms; they may be a minor ridge or a section of an escarpment; a waterhole, a shaft or a cup-like bowl in the rock, symbolising for the artist an event in the journey of that great ancestor. These sites are sacred places and tended by the custodians whenever they can get to them. The opportunity to revisit these sites for ceremonies is seldom missed by religious leaders.

Another aspect of the overhead perspective is the persistent importance of tracks. These are used extensively in the paintings to denote meaning and identify particular ancestors. Paintings utilise accurate representations of the footprints of possums, bandicoots, kangaroos, wallabies, dingoes, emus and birds. The travels of human ancestors or hunters in pursuit of these animals are shown as lines of human footprints. The symbol of the arc indicates a person seated, the arc or U-shape imitates the pattern made in the sand by people when they sit cross-legged. The use of the imprint made by an object on the earth also applies to symbols of camp fires with a circle or cross stick, a digging stick, denoted by a

single bar, or a wooden carrying dish or coolamon, always shown as an oval. The clue to whether the person is a man or a woman lies in the accompanying symbols. Women use coolamons, pitis, and digging sticks, and men have clubs, axes or boomerangs nearby.

Similar symbols are common to all desert paintings — circles, tracks, meandering lines, straight lines, U-shapes or arcs and the imprint of weapons are virtually universal symbols. The specific meaning given to each, however, is generally known in detail only by the artists themselves with clues to its context added within the painting. These clues can be picked up by members of the artist's group with specific knowledge of that dreaming. Hence, for example, a simple painting of concentric circles joined by straight lines with a dotted landscape background could be interpreted in numerous ways by many different groups and could be related to their own respective ancestor's journeys. To give an accurate meaning one would need to know the artist and his or her group and hence connect the painting to the Dreaming concerned. The artist may have given other clues, particular tracks or an ancestor realistically depicted, for example, possum. His or her own kinship group would then immediately begin to tell the story of the possum. The possum ancestor would have stopped at certain dreaming sites so the initiated men could begin to give an interpretation of the canvas.

The symbolism, therefore, is both specific and universal at the same time. The signs themselves are used by everyone but the meaning can be interpreted on a number of levels depending on the relationship of the viewer to the artist. The segmented paintings can be viewed from above, like aerial 'maps' of ancestral journeys across the land, or in detail, marking botanical zones, natural rocks and sites or reflecting the actual vegetation, bushfires, rain patterns or flowers. Dunes, plains, rocky ridges and river courses are marked out. The colours chosen are not necessarily literal interpretations of foliage and colour in the natural landscape but represent changes in tone and pattern, although many of the strong blues and purples used could reflect actual colours like the soft purple haze of a clay pan at dawn or the vivid blue of 'Patterson's Curse' or the red of the rampant introduced 'hop-bush'.

THE MODERN MOVEMENT

The desert painting movement only began in 1971, with the stimulation of a local art teacher at Papunya, Geoff Bardon. He had begun to encourage the children to paint a mural on a school wall using geometric shapes and symbols such as circles and tracks. Some of the older men were watching from the distance and became intrigued. Upon coming closer, and with encouragement, they took over the task of painting and completed a traditional honey ant design over the whole surface. Within only a couple of months, this depressed desert community at Papunya had become infused with fervour to paint, as up to 20 artists began to cover every available scrap of masonite or board producing numerous paintings about their religious beliefs and land using completely traditional symbols.

Within a few years the paintings had developed to the point where artists were making completely articulated large abstract canvasses which stunned the 'outside'

viewers. Today hundreds of artists, both men and women, paint throughout the desert areas in approximately a 400km radius from Alice Springs. The areas include Pintupi, Warlpiri, Luritja, Anmatyerre, (Arrernte) and Pitjantjatjara tribal lands. In fact, every settled desert group today, whether in an outstation, a cattle property or in a town community numbers artists among its members. Painting has become not only important education work in teaching young children the oral history, law and land — it helps the spirit too. Recreating segments of song cycles in paint, or simply depicting a nest of honey ants under the ground is far more satisfying than receiving 'sit down money' — government unemployment pensions.

The education aspect involved in the contemporary painting movement is increasingly the means by which young children are learning details of religious and ritual knowledge outside the context of song and ceremony. These days conventional schooling is provided for desert children in a bi-lingual framework and for a period communities worried about the erosion of time this caused in the children's time with their mothers primarily, and other kinship members who might teach them important techniques for survival as well as religious knowledge. By sitting around at home watching paintings being executed and, in particular with the increase of women's participation in the modern painting movement, children have access to a great deal of ritual and symbolic knowledge at all times of the day. When a painting is in progress an artist will point to features of the landscape explaining the meaning so that children can understand.

The richly coloured ranges near Papunya give Dreaming inspiration to the artists.

The modern paintings are for the most part motivated by a creative desire to communicate important truths. Although the economic motive is always present as well, women's paintings, increasing in numbers in the latter years, are often fresh and joyful interpretations of aspects of the landscape, particularly bush tucker.

There is no doubt that the contemporary desert painting movement is a continuation of the strong religious tradition. Most are done in a contemplative frame of mind, either by single artists or groups of relatives. Touching, chanting, talking and teaching are part of the group's activity. The religious paintings of a more important, serious nature are often watched by 'guardians', the Kutungulu of the sites concerned and if paintings are exchanged for large amounts the Kutungulu will seek their share, not as artists but for their equity in the religious knowledge exchanged.

DOTS, CIRCLES AND LINES

Why are these works constructed of dots? There are several answers. The practice of painting with an implement like a brush is new to desert artists — their art comes from the landscape itself, from the designs constructed on the flattened earth around which the dancers and singers perform during ceremonies. These ground constructions or 'sand paintings' are not of sand, but of pulverised plant and animal material mixed with coloured ochres. This wet substance, similar in texture to *papier maché,* is placed on the ground by hand, dot by dot — and when the modern artists began to use acrylic paint on canvas and board with brushes and sticks, many imitated this process. The technique became a sort of trademark and other artists followed.

Another logical reason for the painters' technique is offered in the appearance of nature itself. The landscape is very 'dotted'. The appearance of spinifex growing in clumps on the plains and low rocky ridges, or burnt out country after fire is remarkably similar to the effect created in the dotted areas on many canvasses. Each desert artist paints subjects drawn from his or her own country: their own landscape (both the reality of the vegetation and structure and the 'inner landscape' of the mind) and their knowledge, passed on over countless generations of how this land was made and how it should be cared for. Although today this knowledge is still passed on in songs, ceremonies and oral history, it is increasingly conveyed through art as children sit near their parents and have the meanings of the designs explained while the painting progresses.

The 'journeying' ancestral paintings are a way in which the artist can relive past travels from one sacred place to another. It is common to see artists commence a painting beginning at one site, a concentric circle at the edge of the canvas closest to the artist. As the painting progresses the artist fills in the landscape encountered by the key characters along their journey. Tracks begin to appear to and from waterholes: possum tracks for possum dreaming, emu tracks, bandicoot tracks, or human footprints, and then, as the group reaches another special site the artist will begin a second concentric circle and so on. Painters seldom plan or map out the entire painting across the canvas but journey from one edge to the other, filling in the landscape as they go.

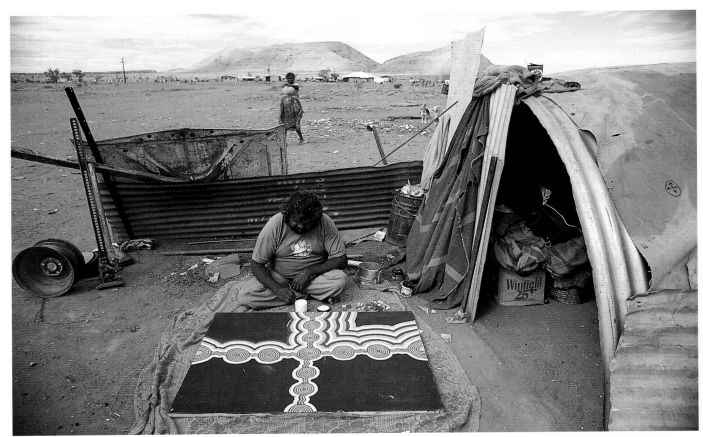

Shorty Jackson Tjampitjinpa paints outside his home at remote Kintore, north west of Alice Springs.

THE WIDESPREAD DESERT ART MOVEMENT

Today many stylistic differences can be discerned between language groups and as the communities tend to paint as groups, these become reinforced. Communities which now exhibit together include Papunya, Yuendumu, Mt. Allen, Napperby Station, Warburton, Lajamanu, Balgo and the Pitjantjatjara through Maruku, Ayers Rock. Other paintings are frequently done by individuals outside the established communities and sold at stores, roadside areas or petrol stations on many desert roads, particularly along the main highway between Alice Springs and Darwin. These works, of course, vary enormously in their quality.

In Alice Springs, the town centre for desert artists, major galleries include the centre for the Papunya Tula company, the original company formed by the artists at Papunya. As well, Aboriginal Arts Australia's gallery services visitors and artists from Aboriginal communities in and around Alice Springs. Artists are increasingly purchasing their own canvases or being supplied these by competitive galleries eager to secure the goodwill and co-operation of major painters. Painters in Alice Springs include many innovators and new artists among their ranks, particularly young women.

If the environment undergoes climatic upheaval, the painting subjects reflect this. Alice Springs was recently awash in floods and from the air the surrounding desert country looked like lakelands. To the artists it was therefore logical that their paintings would begin to celebrate the spawning of fish in waterholes and when many suddenly became turquoise green with pink and irridescent fish around the edges this caused some amazement in art circles.

Alongside the vital new paintings of vivid colour, acid greens, psychedelic pinks, flowers and realistic images, the original men who began Papunya Tula have returned to Kintore and surrounding outstations and continue to paint their great Tjingari cycles, recording the journeys of their ancestors in religious symbols that link the present with the 10 000 year old past of the rock engravings.

In recent years wider experience of the world and contact with people have produced many stylistic changes and occasionally the incorporation of political statements. Artists have won Australian art prizes, including the Alice Springs Art Award and the Northern Territory Art Award. They have shown at the Biennale of Sydney, and are prominent in many international exhibitions of Australian contemporary art. They have also achieved success in the international arena, and major works are selling for prices which rank them with other modern masters of Australian art.

In 1988, one artist, Michael Nelson Tjakamara achieved prominence through the execution of a major design of his for the new Parliament House — the mosiac forecourt.

In addition Tjakamara painted a major mural for the Sydney Opera House. He has commented about the relationship of religion to the new commission:

> "Now we want to show our paintings to everybody: show them to the world. We want to tell people that this is a most important place to us. This is land! They have taken it away from us and they didn't even think about it! This is the reason why we now want to show the world our dreamtime culture, so that they can understand our way of life. They are probably starting to think back now on what has been happening to Aboriginal people. So this Possum Dreaming is not just a beautiful wall in the Opera House — it will make people think."[2]

Compared with other forms of Australian traditional art the new acrylic painting movement has dominated public awareness with its arresting vitality and strength. As a by-product, Aboriginal children are encouraged to see the wider value of retaining and upholding their parents' traditions and religious beliefs about the landscape in the face of increasing pressures from the wider world.

SHORTY LUNGKATA AND OTHERS

Group or Language: PINTUPI
Area: PAPUNYA

This work was one of the largest canvases to be painted at Papunya in the 1970s. Several men completed the work, each contributing a section, but all working around the canvas simultaneously.

The stories form part of a cycle of sacred ancestral journeys and few specific details were recorded at the time, other than that the concentric circles mark sites where the men and women ancestors paused or where incidents happened in the Dreaming, creation era. The ritual sites depicted are close to the Kintore Ranges. At the time of painting all artists were resident at Yayayi bore.

FOUR DREAMINGS 1978

(240 x 300 cm)

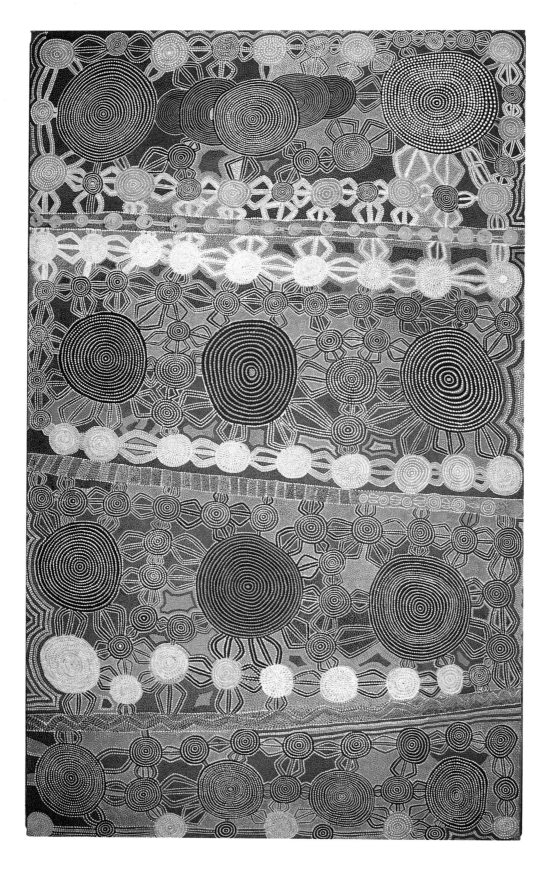

TIM LEURA TJAPALTJARRI

Group or Language: ANMATYERRE/ARANDA
Area: PAPUNYA

The seven sisters constellation or the 'Pleides' is a group of important women ancestors who travelled far across the western desert down to Pitjantjatjara country and finally rose into the sky where they shine today.

The painting shows the artist's birthplace, Kooralia, on Napperby Station. Kooralia is the name given to the seven sisters. The landscape shown is the creek bed and sand dunes.

Tim Leura was one of the first Papunya artists, and a great lyrical painter.

THE SEVEN SISTERS 1980
Private Collection (183 x 152cm)

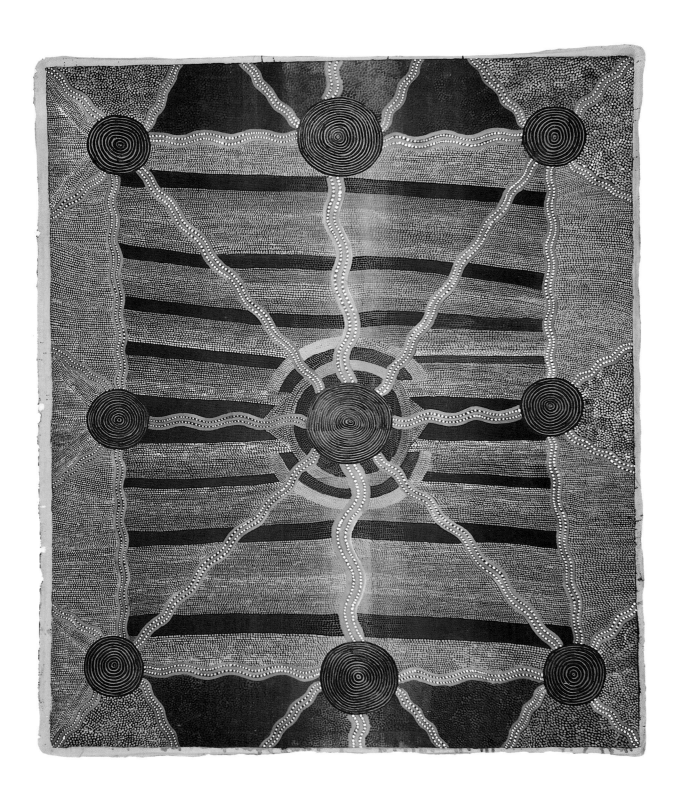

PADDY CARROLL TJUNGURRAYI

Group or Language: ANMATYERRE/WARLPIRI
Area: PAPUNYA

Budgerigars are symbols of ritual knowledge and are believed to fly from group to group distributing information.

Ceremonies are held for the budgerigar dreaming at Tjunti, to the west of Central Mt. Wedge, in the Northern Territory. The designs used for ground constructions and on the body are reflected in this work which records the area around Tjunti and the budgerigar ancestor journeys to that site.

BUDGERIGAR DREAMING 1983

Private Collection (182 x 152cm)

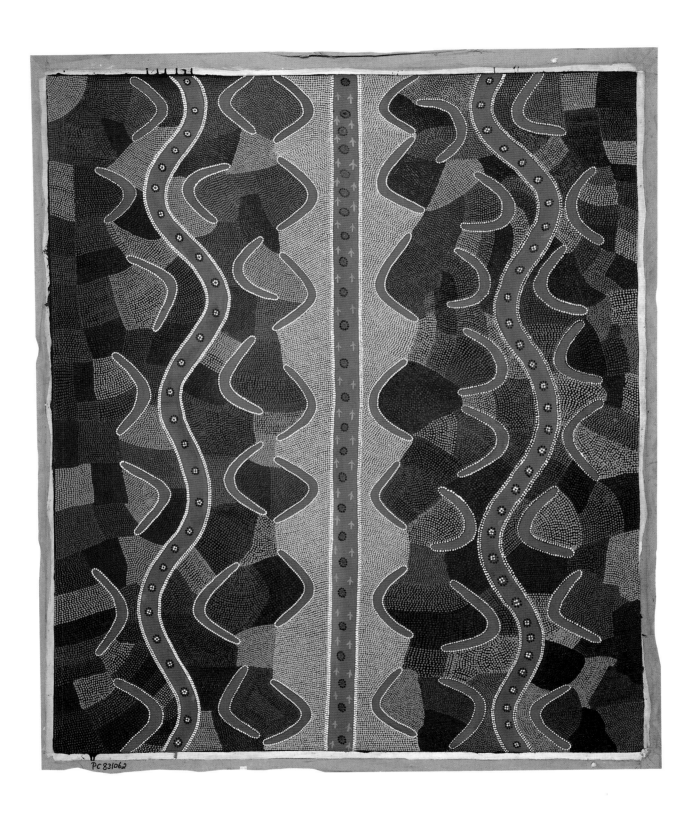

PC 83106.2

25

Paddy Carrol Tjungurrayi

Group or Language: ANMATYERRE AND WARLPIRI
Area: PAPUNYA

This painting depicts ceremonies at a Kunatjarri cave which is close to Central Mt. Wedge, a major site north of Alice Springs.

The formal symmetry and simplicity of this composition characterises Paddy Carrol's work.

Although relatively young, the artist has been a prominent member of the Papunya-Tula artists company since the mid seventies.

The design is a ground design used in ceremonies for witchetty grubs. The grub ancestors emerged from Kunatjarri, the central roundel, in the creation times after which two became snakes. The wavy lines represent snakes.

WITCHETTY GRUB DREAMING 1980s

Department of Aboriginal Affairs

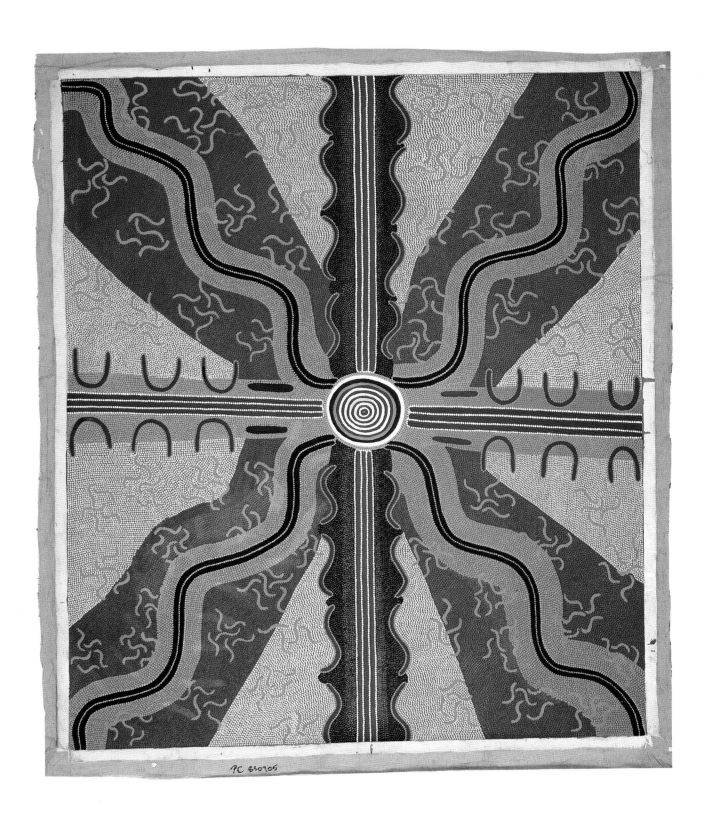

PC 830905

27

OLD MICK TJAKAMARRA

Group or Language: WARLPIRI
Area: PAPUNYA

The Honey Ant Dreaming is associated with the site of Papunya itself. The ants store nectar in their distended abdomens, and are dug from underground chambers. In many desert areas they are a special traditional food due to their sugary contents.

The painting represents three Honey Ant Dreaming sites and seated participants as U-shapes around them. The small stemmed plant is pulverised and used as the raw material to make the ground design for the ceremony in progress.

HONEY ANT DREAMING 1982
Private Collection (91 x 68cm)

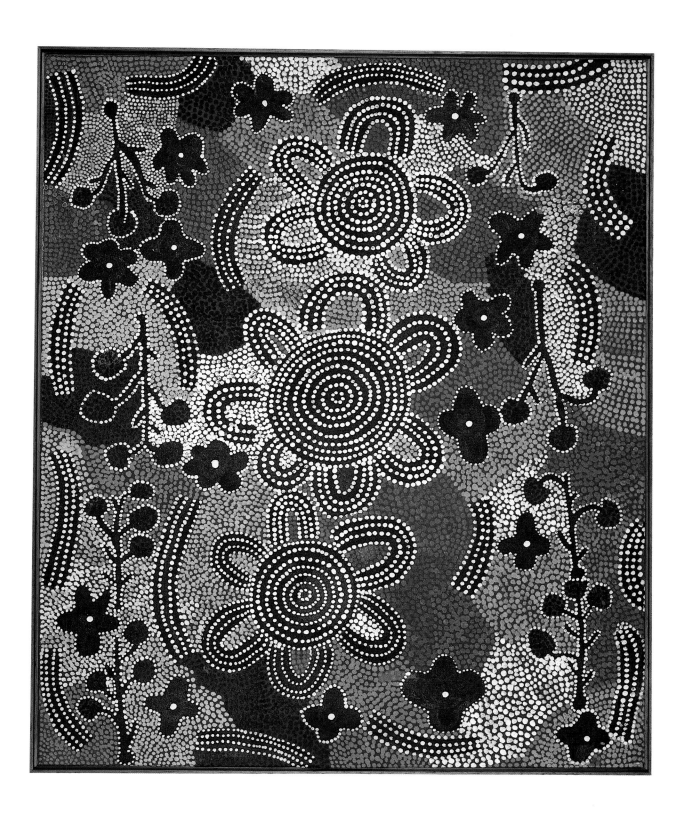

NOLAN TJAPANGATI

Group or Language: PINTUPI
Area: WESTERN DESERT

These paintings are derived from ancient ground or sand paintings and from body decoration. The artist has depicted the soakage water site of Pilmanya which is situated in a rocky outcrop.

In mythological times a large group of Tingari Men gathered at this site. Tingari is the ancient and secret post initiatory higher education undergone by Aboriginal men of the region.

PILMANYA WATER SOAKAGE 1982
Private Collection

30

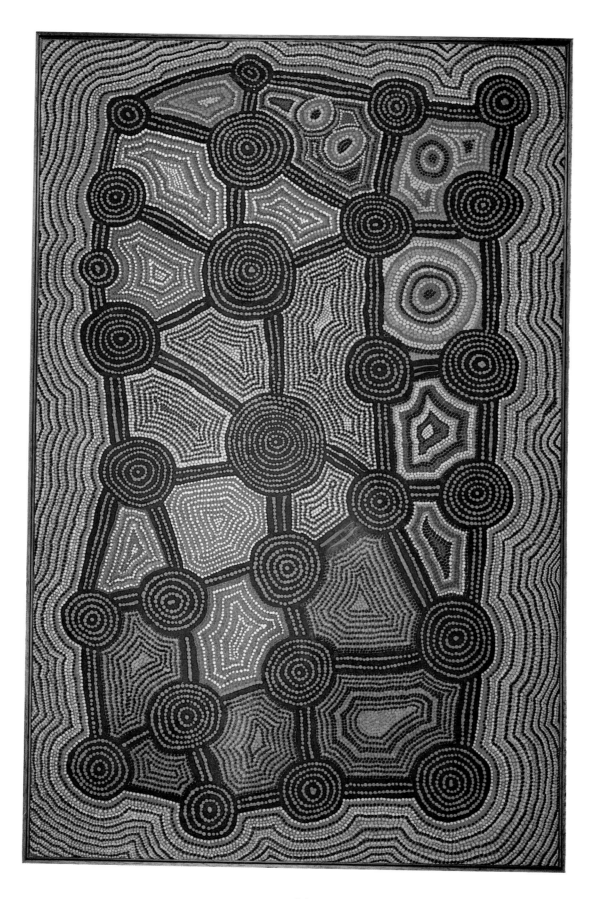

Yala Yala Gibbs Tjungurrayi

Group or Language: PINTUPI
Area: PAPUNYA

The Tingari stories recount the creation-time travels of a particularly important group of elders who taught ritual knowledge to initiates.

This painting depicts events at Kaakorotintja site near Lake Macdonald in Western Australia. Part of the song cycles recall how the lake once rose after heavy rain and drowned many Tingari men.

TINGARI CYCLE 1982

Private Collection (102 x 162 cm)

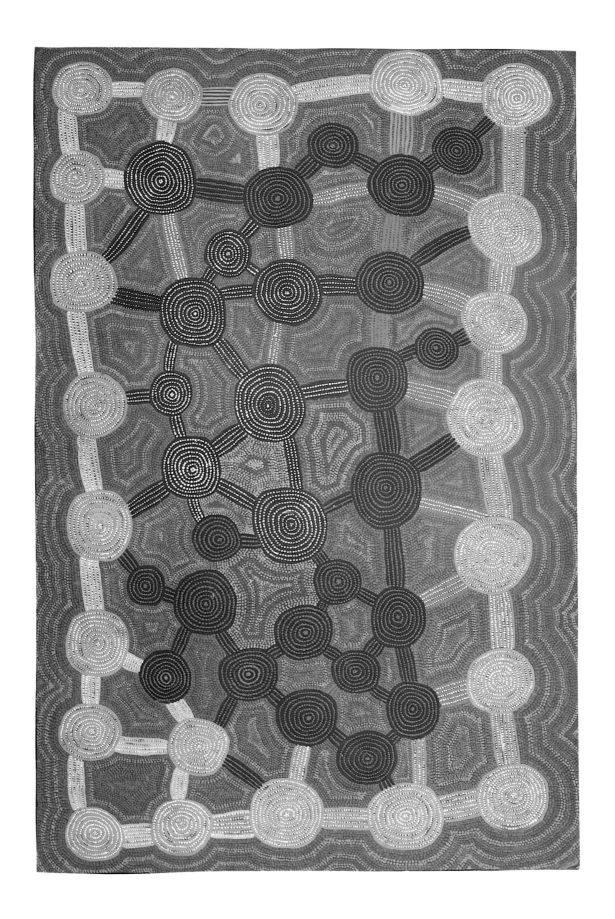

YALA YALA GIBBS TJUNGURRAYI

Group or Language: PINTUPI
Area: PAPUNYA

The snakes depicted in this painting are Wanampi, mythical Rainbow Serpents. They are shown at Patjantja, a soakage west of Kintore in the Gibson Desert. Concentric circles represent the waterholes at this site, and the background patterns indicate sandhills. The story associated with this painting belongs to the Tingari Cycle, details of which are secret-sacred, hence no further information could be given.

Generally, the Tingari are a group of mythical characters of the Dreaming, who travelled over vast stretches of the country, performing rituals and creating and shaping particular sites. The Tingari men were usually followed by Tingari women and accompanied by novices and their travels and adventures are enshrined in a number of song cycles. These mythologies form part of the teachings of the post-initiate youths today as well as providing explanations for contemporary customs.

WANAMPI SNAKES 1987
Courtesy Gallery Gabrielle Pizzi

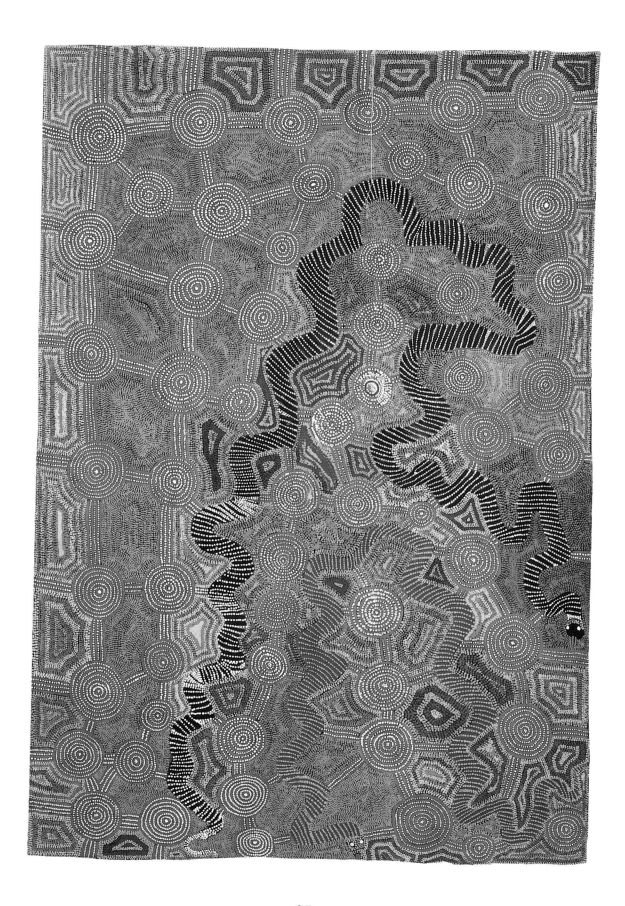

MICK NAMARARI TJAPALTJARI

Group or Language: PINTUPI
Area: PAPUNYA

This painting depicts a Women's Dreaming at a site to the south of the Kintore Ranges. The Tjalapa (small blue tongue lizard) Dreaming also passes through this site.

The background design in this work shows the sandhills which surround the site.

WOMEN'S DREAMING AND TJALAPA 1983
Private Collection

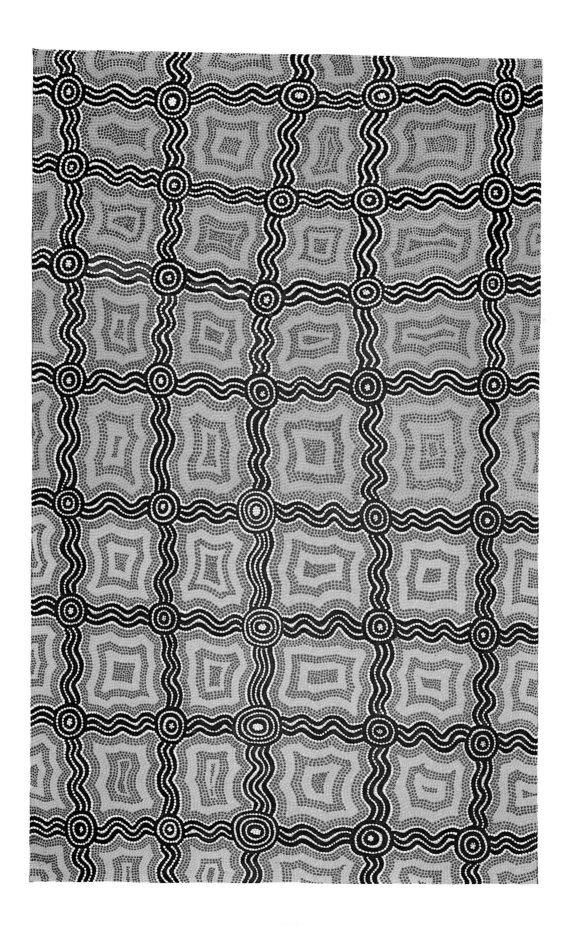

MICK NAMARARI TJAPALTJARI

Group or Language: PINTUPI
Area: PAPUNYA

This painting is a celebration of the Whirlwind Dreaming associated with the site of Watukurri, south of the Kintore Community.

The roundels indicate the places where the wind originates and the sinuous lines show the wind. The artist called the centre of the whirlwind the eye and said the painting also shows the dust rising with the wind.

WHIRLWIND DREAMING 1986

Courtesy Gallery Gabrielle Pizzi

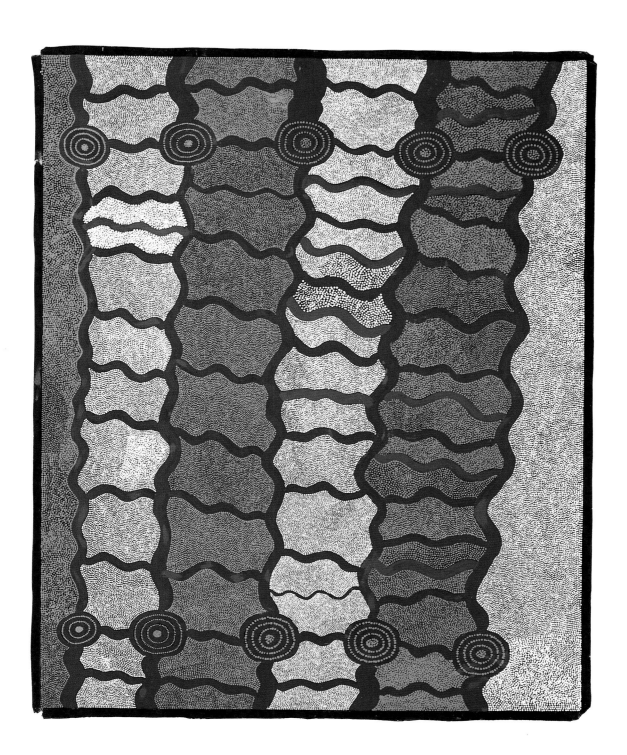

WILLIAM SANDY

Group or Language: PITJANTJATJARA
Area: PAPUNYA

The Pitjantjatjara homelands cover an extensive area to the south of the Northern Territory, and extend into Western Australia and South Australia.

This painting represents the journeys of the dingo ancestors, whose footprints are centrally shown. They travelled to Wingellina, near the borders of the three states.

The human footprints record the major creation journey undertaken by the two women Kungka Kutjarra and their travels from waterhole to waterhole over a vast area of desert.

DINGO DREAMING 1983
Private Collection (129 x 76cm)

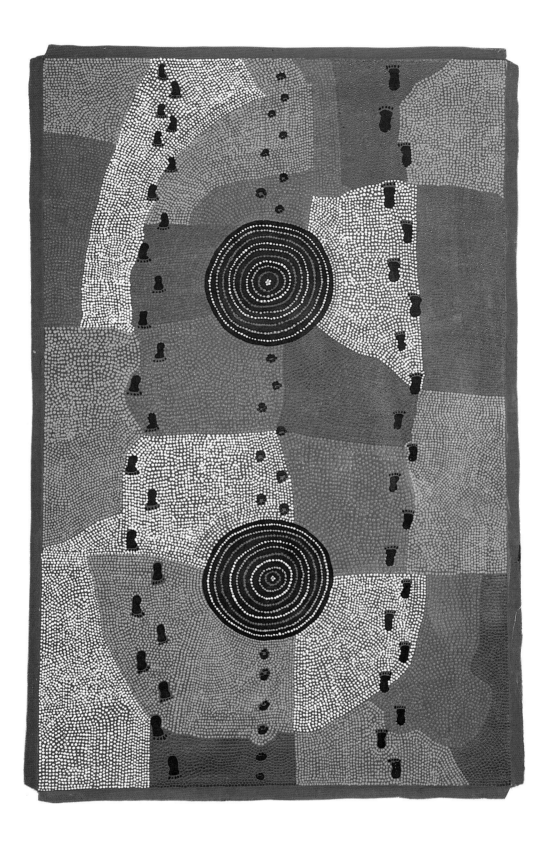

Tommy Lowry Tjapaltjarri

Group or Language: PINTUPI
Area: PAPUNYA

The subject of this painting is Warrmala, a Wanampi, or Rainbow Serpent. Warrmala is depicted at Patjarrnga, a deep waterhole near Warakurna, Western Australia.

From Patjarrnga, the Rainbow Serpent travelled on to Pukaranya, near the Warburton Ranges.

WARRMALA THE SERPENT 1986

Courtesy Gallery Gabrielle Pizzi

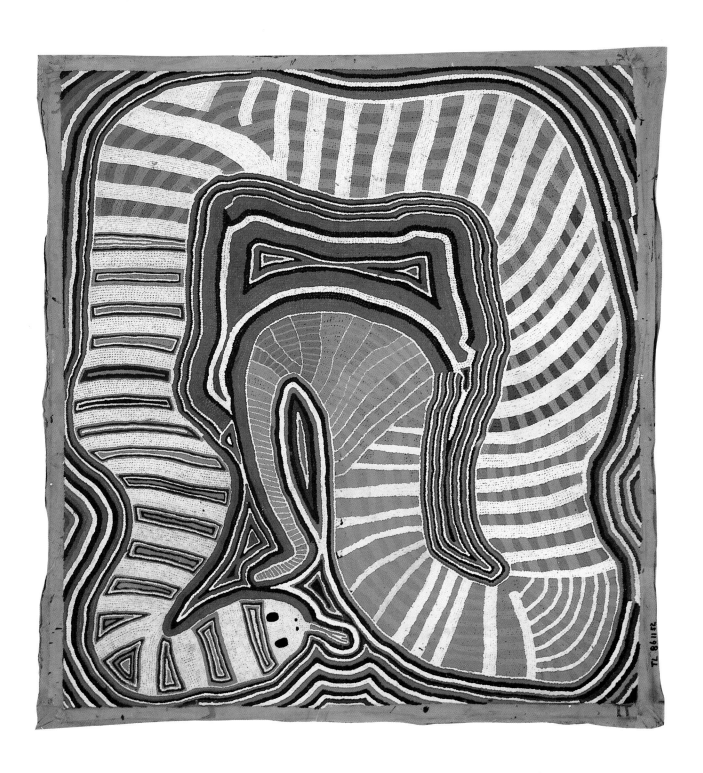

43

TOMMY LOWRY TJAPALTJARRI

Group or Language: PINTUPI
Area: PAPUNYA

The design elements in this work represent the Moon Dreaming at the site of Tjunpaninga to the south of Kintore.

An old woman of the Nangala kinship subsection was sleeping at this site. The circle is her camp and the arcs show where she slept. The straight lines represent the sound passage of the voice of the Moon Ancestor.

After camping here for some time the old woman travelled across the sky to a site further south.

VOICE OF THE MOON 1987
Courtesy Gallery Gabrielle Pizzi

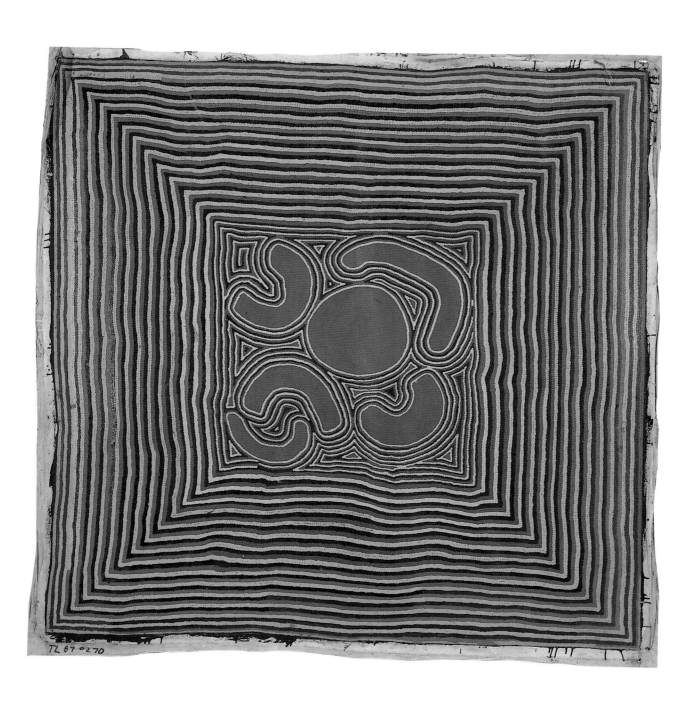

TL 87 0270

45

CLIFFORD POSSUM TJAPALTJARRI

Group or Language: ANMATYERRE
Area: KINTORE

The painting concerns women's ceremonies at Nyilli on Mt. Allen Station in the Northern Territory.

The U-shapes are seated women preparing for the ceremony and the circles are the site. It is usual for women to commence major ceremonies by sitting together chanting song-cycles which tell of journeys which bring the creation ancestors close to the site. Then the ceremony begins.

WOMEN'S CEREMONIAL DESIGN 1983

Queensland Art Gallery (183 x 152cm)

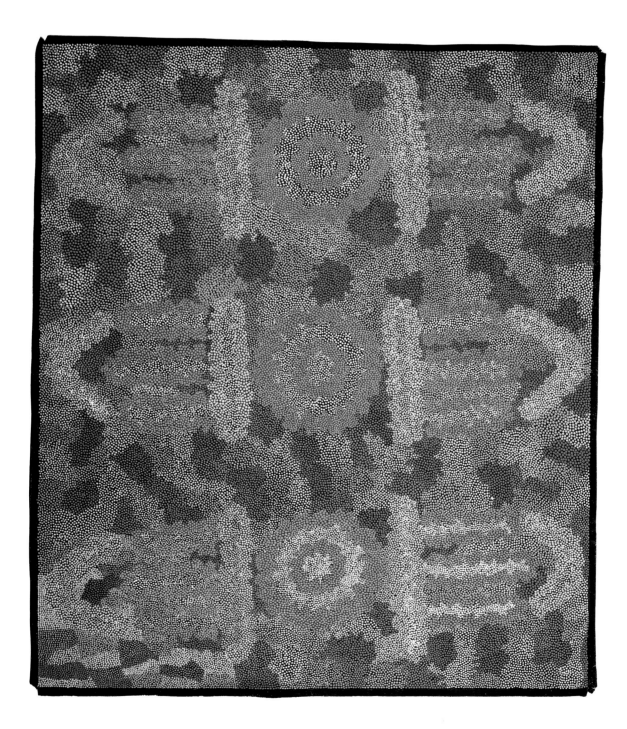

CLIFFORD POSSUM TJAPALTJARRI

Group or Language: ANMATYERRE
Area: PAPUNYA

The painting is inspired by ground designs and body designs used in Bushfire Ceremonies at a site near Napperby (central concentric circle).

The custodians of this dreaming, of the Tjampitjinpa and Tjangala kinship sub-section, are preparing for the ceremony. Their bodies are being painted by Tjapaltjarri, the guardian of the dreaming. It is his responsibility for everything to be carried out correctly. All the men are represented by U-shapes.

Also shown are the hairstring belts worn during ceremony.

The dancing takes place the night before a controlled bushfire is lit. The background colours depict the countryside after the fire.

Clifford Possum is considered one of the finest artists from Papunya, and is chairman of Papunya-Tula.

BUSHFIRE DREAMING 1988

Courtesy Centre for Aboriginal Artists, Alice Springs

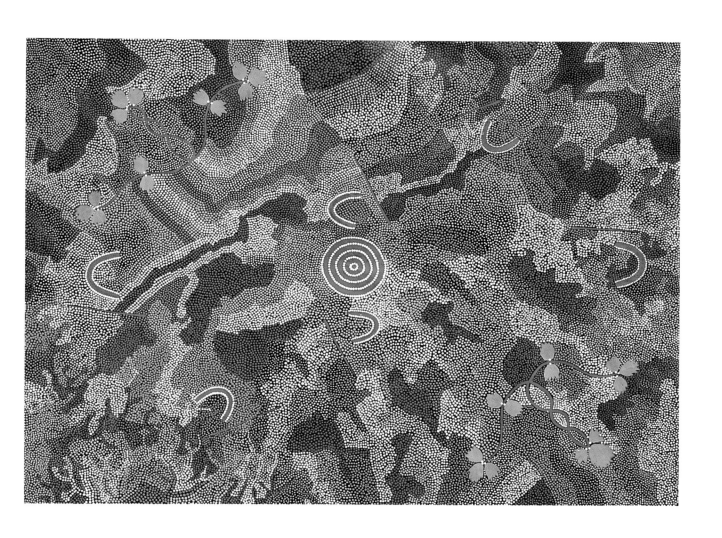

UTA UTA TJANGALA

Group or Language: PINTUPI
Area: PAPUNYA

This painting depicts designs associated with the secret-sacred Tingari ceremonies at the site of Kanaputa in the vicinity of Lake Mackay. The roundels represent the swampy area near the site and the lines through the centre of the work are a ceremonial pole. Generally, the Tingari are a group of mythical characters of the country, performing rituals and creating and shaping particular sites. The Tingari men were usually followed by Tingari women and accompanied by novices. Their travels and adventures are enshrined in a number of song cycles. These mythologies form part of the teachings of the post-initiatory youths today as well as providing explanations for contemporary customs.

TINGARI CEREMONIES AT KANAPUTA 1986
Courtesy Gallery Gabrielle Pizzi

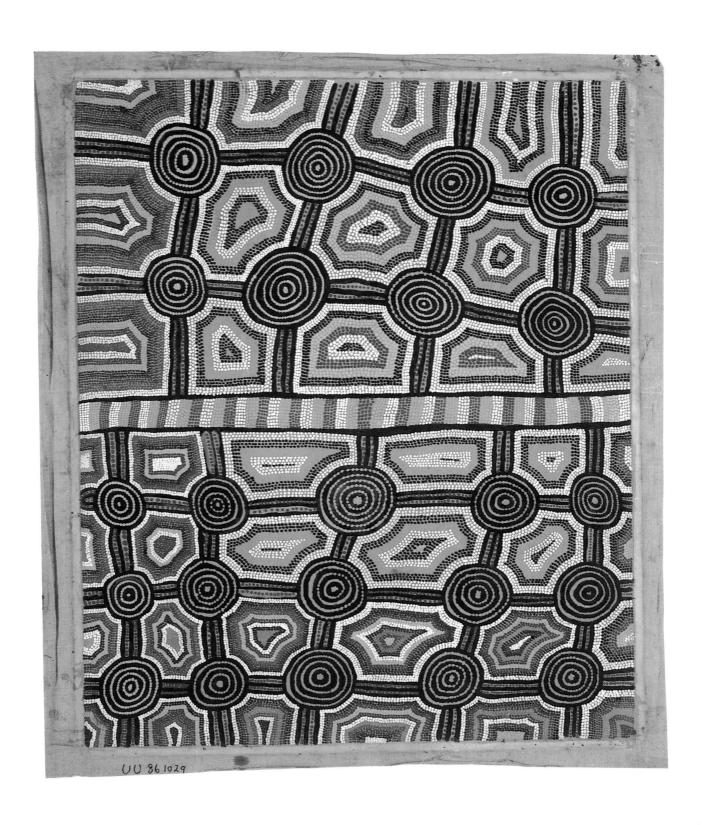

UU 86 1029

51

Two Bob Tjungurrayi

Group or Language: WARLPIRI
Area: PAPUNYA

This painting is associated with the mythology of Winpirrinpa, a small reddish coloured snake which lives in the sandhill country in the vicinity of Yarrapalangu, to the north-west of Papunya Community. This snake can be heard making noises at night.

The roundels represent the holes in which the snakes lives. The small S–shapes represent Anyamarra, a green caterpillar.

As these specific ceremonies are associated with the initiation of youths, and are therefore of a secret nature, the artist did not reveal any further detail.

WINPIRRINPA SNAKES 1986
Courtesy Gallery Gabrielle Pizzi

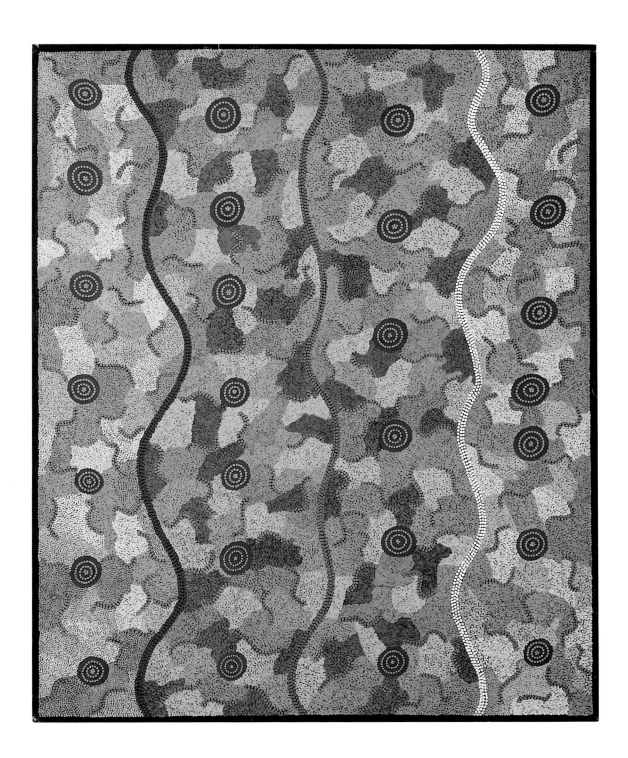

PANSY NAPANGARDI

Group or Language: WARLPIRI-LURITJA
Area: PAPUNYA

This is a Women's Dreaming from Winpirri rockhole, far to the north west of Alice Springs. The story belongs to the artist's mother and maternal grandfather.

At the top right-hand corner an old man (the U-shape) is sitting watching his two daughters, also symbolized by U-shapes, making a campfire, the central roundel. The old man is shown with his hunting weapons, boomerangs, shield and spears. Running the length of both sides are two sinuous lines. These are woven hair-strings.

Further details are secret-sacred and were not revealed.

WOMEN'S DREAMING AT WINPIRRI ROCKHOLE 1986
Courtesy Gallery Gabrielle Pizzi

54

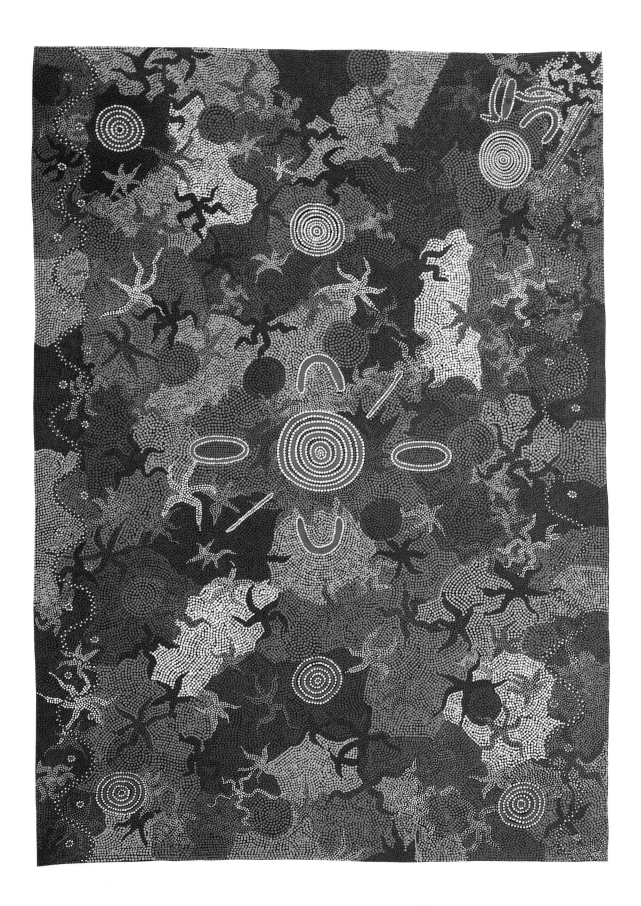

KEITH KAAPA TJANGALA

Group or Language: WARLPIRI
Area: PAPUNYA

The witchetty grub is an important desert staple food and a major Warlpiri creation being. The painting records a site called Yalukari, west of Yuendemu where the moths emerged from their pupae cases, and flew away.

In the larval form, the grubs eat the core of the roots of certain acacia bushes, shown as smaller outer circles. The ceremonial ground for the witchetty dreaming is depicted by the roundels around the centre.

WITCHETTY GRUB DREAMING 1983
Private Collection (122 x 91 cm)

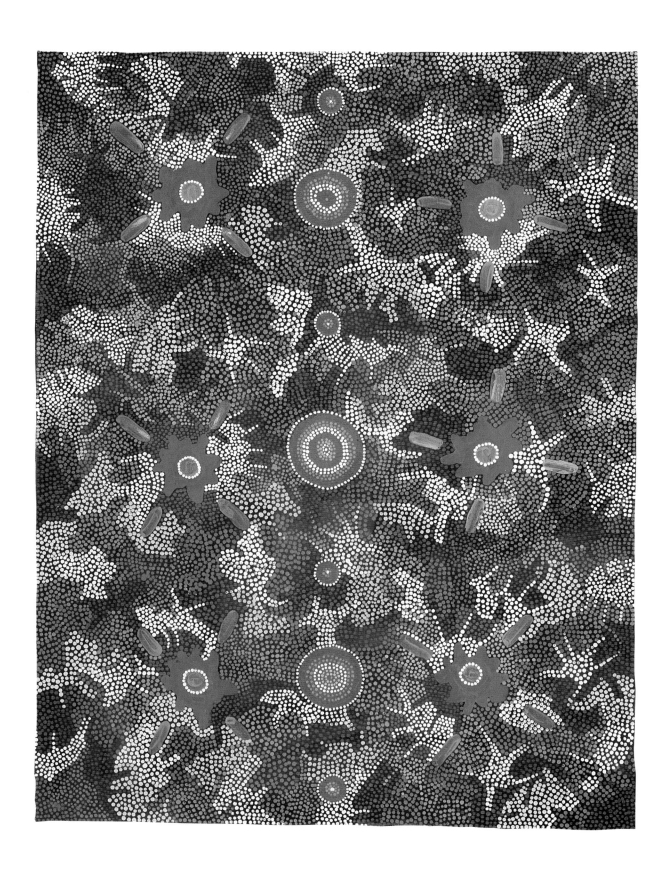

Brenda Lynch Nungurrayi

Group or Language: ANMATYERRE
Area: NAPPERBY STATION

The painting depicts an incident from the artist's grandfather's dreaming. At Coniston Station there are now permanent waterholes at the site where Water Snake Ancestors live. These are represented by the three blue and white circles. The white oval shapes are the snakes' ribs.

There are two male and two female snakes. The custodians of this dreaming perform ceremonies at various times of the year to celebrate the Snake Dreaming.

WATER SNAKE DREAMING 1987

Courtesy Centre for Aboriginal Artists, Alice Springs

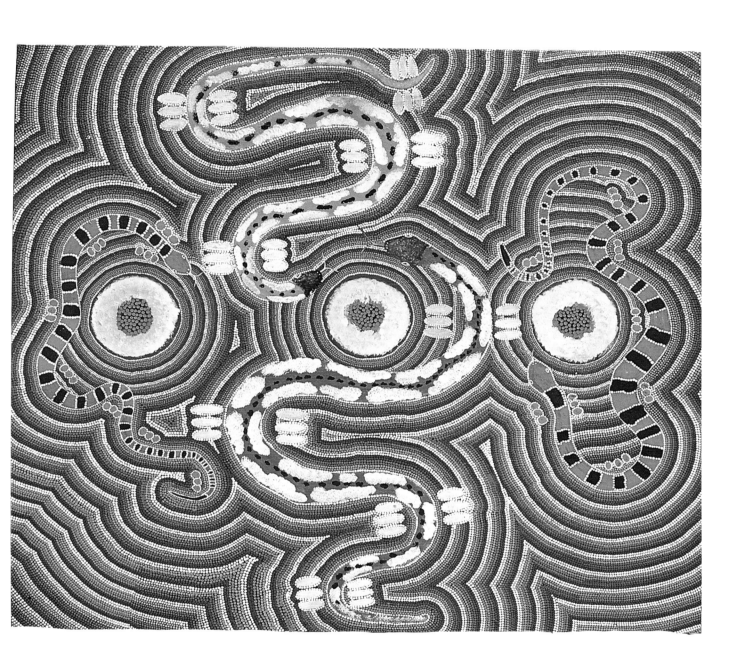

RILEY MAJOR TJANGALA

Group or Language: PINTUPI
Area: PAPUNYA

This painting concerns four snakes who emerged from a spring at Piltadi, a site south-west of Papunya. This site is represented by the middle roundel. Men from the Tjupurrula and Tjakamarra kinship subsections entered the ground as wind at the places represented by the four corner roundels. They later emerged as men. The tracks of these men can be seen as they travelled to Piltadi. As this site was forbidden to those men, the four snakes descended on them and drowned them in the spring.

The background is sandhills.

This story is part of the secret-sacred mens' Tingari Cycle, so no further detail was given.

FOUR SNAKES AT PILTADI 1986
Courtesy Gallery Gabrielle Pizzi

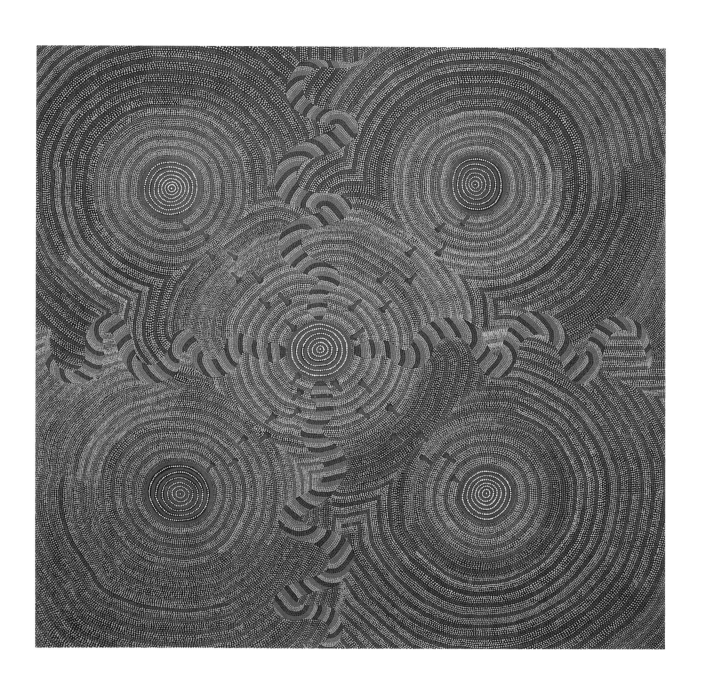

Entalura Nangala

Group or Language: LURITJA
Area: PAPUNYA

This is an important dreaming of Papunya which literally translated means 'honey ant place'.

The concentric circles depict sites along the path of the Honey Ant Ancestors (horseshoe shapes), as they travelled through this region. The radiating arc shapes are body paint designs worn by women during honey ant ceremonies.

Entalura Nangala was one of the first women to paint solo works at Papunya (1982-83), thereby opening the way for many others.

HONEY ANT DREAMING 1987
Courtesy Centre for Aboriginal Artists, Alice Springs

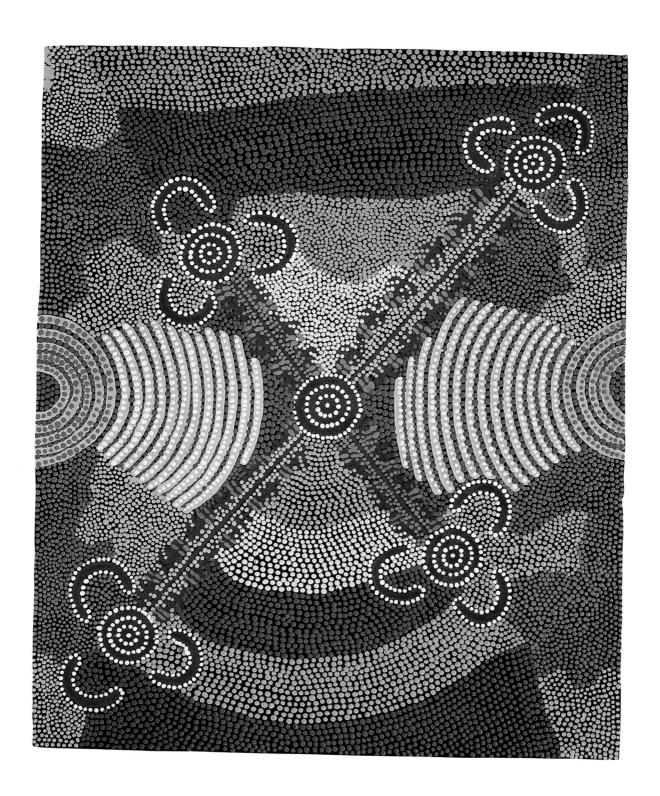

BILLY STOCKMAN TJAPALTJARRI

Group or Language: ANMATYERRE
Area: PAPUNYA

This dreaming is near Ylpana, or Mt. Denison. This is an important dreaming site to men of the Tjungurrayi/Tjapaltjarri skins. The carpet snake is seen encircling his home, the central circles. Men perform ceremonies here today. The linked background circles are of symbolic meaning and used as body paint designs during ceremonies.

CARPET SNAKE DREAMING 1987

Courtesy Centre for Aboriginal Artists, Alice Springs

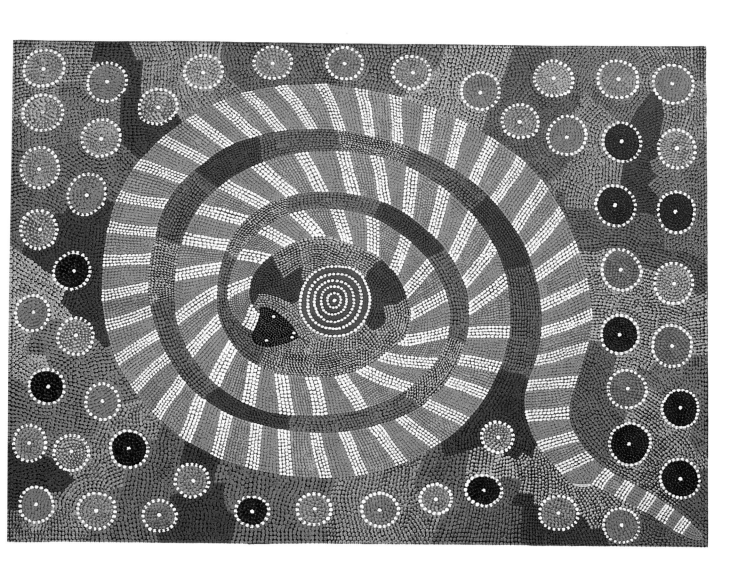

Billy Stockman Tjapaltjarri

Group or Language: ANMATYERRE
Area: PAPUNYA

The painting concerns the journeys of Mamaboomba, Spider Ancestors from Mt. Denison to Kurrin yerra (Central Mt. Wedge).

During the ceremony the custodians of this dreaming, Tjungurrayi and Tjapaltjarri sit around a symbolic spider's hole (sacred site) and sing. They then become one of the totem. The black spider shapes represent the mens' body designs worn for this ceremony.

Other ceremonial items such as human hair string belts decorated with white cockatoo feathers, yam sticks and quartz stone knives are also shown.

The artist is the senior custodian of this dreaming.

Billy Stockman Tjapaltjarri is one of the first painters at Papunya and therefore a forefather of the contemporary art movement. He is represented in many major collections in Australia and abroad.

MAMABOOMBA TJUKURRPA 1988
Courtesy Centre for Aboriginal Artists, Alice Springs

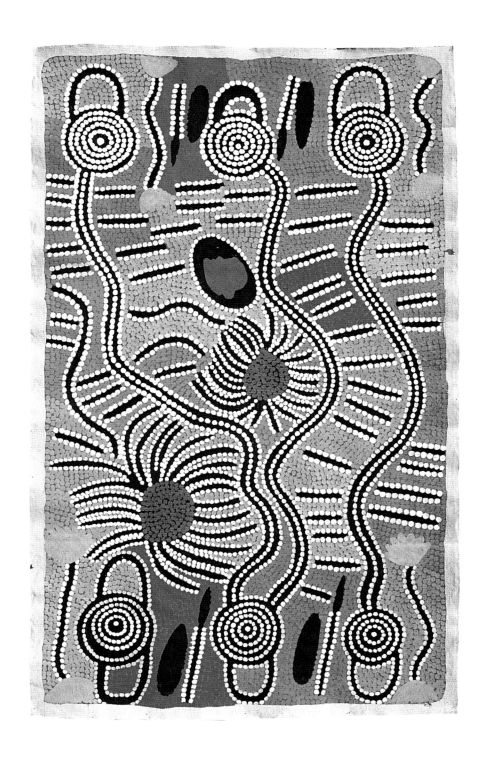

MICHAEL TOMMY TJAPANARDI

Group or Language: ANMATYERRE
Area: MT. ALLAN

The location of this painting is Mt. Allan, the artist's father's country. Two large perenties are naturalistically depicted around one of their homes (concentric circles). The small oval shapes are the perentie's tracks and the white shapes are other evidence left by the perentie. The U-shapes are the seated perentie ancestors.

PERENTIE DREAMING 1987

Courtesy Centre for Aboriginal Artists, Alice Springs

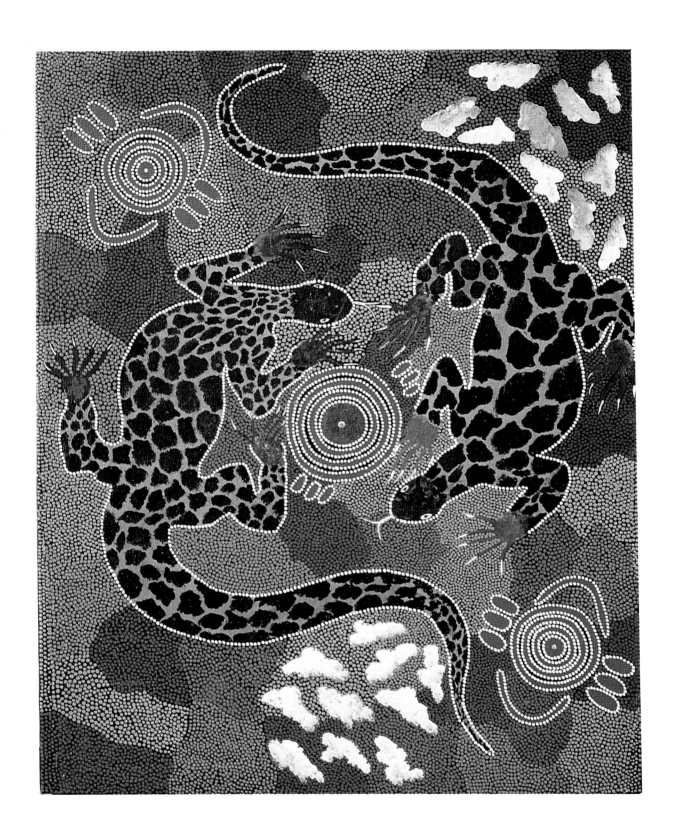

Johnny Warrangula Tjupurulla

Group or Language: LURITJA
Area: PAPUNYA

The subject of this painting is a Rain Dreaming, Kalipimpa, in the artist's country, north of Kintore.

The sinuous lines represent water flowing after rain. The background is lush vegetation and abundant bush foods.

Pelican tracks are also depicted as this aquatic bird only appears after rain.

RAIN DREAMING 1987

Courtesy Centre for Aboriginal Artists, Alice Springs

NORA ANDY NAPALTJARRI

Group or Language: WARLPIRI
Area: MT. LIEBIG

The location of this painting is Kurrin yerra or Central Mt. Wedge, a magnificent mountain formation north east of Papunya, and approximately 300 km north west of Alice Springs. This is Nora's father's dreaming site and closely connected with the dreaming of the wild bush onion, an onion grass known to the Warlpiri as 'Janmarda' but often referred to by the Aranda name 'Yelka' (*Cyperus rotundus*).

The central circle represents the site where an aunt and niece of the kinship subsection groups, Napaltjarri and Nungurrayi are digging for wild bush onions. The women are depicted by the U-shapes beside their coolamons and digging sticks. The four outer circles are the edible bulbs.

JANMARDA DREAMING 1988

Courtesy Centre for Aboriginal Artists, Alice Springs

72

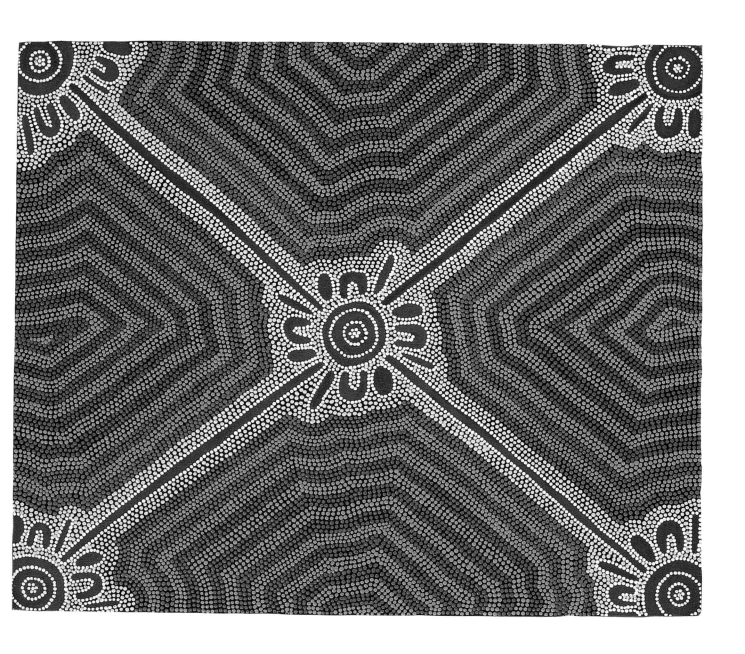

Faye Brown Napaltjarri

Group or Language: WARLPIRI
Area: LAJAMANU

Honey ant ancestors emerged from the site of Yuelamu or Mt. Allan during the Creation Era and continued to travel underground west towards Papunya and Yuendumu. Their underground chambers created natural soakages.

In this painting, located in the artist's father's country in the Tanami Desert near Rabbit Flats, the central concentric circles represent the hole where the honey ants 'Yunkurranyi' enter the ground and the adjoining lines are the underground tunnels.

HONEY ANT DREAMING 1988

Courtesy Centre for Aboriginal Artists, Alice Springs

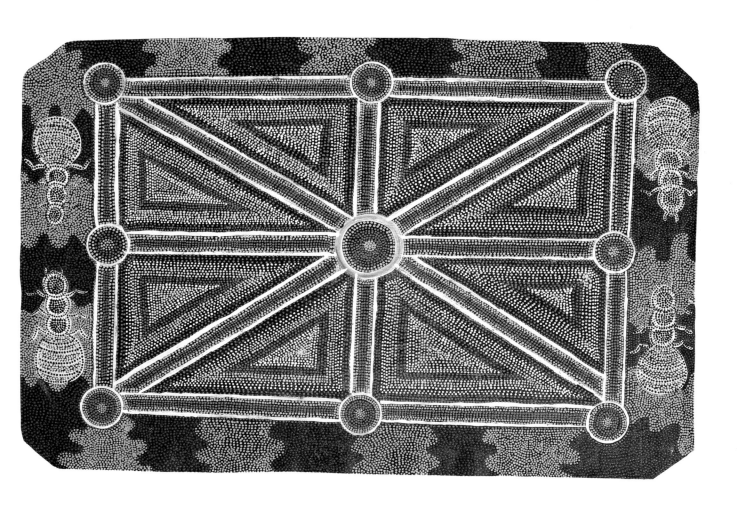

Barney Daniels Tjungurrayi

Group or Language: LURITJA
Area: HAASTS BLUFF

In this painting the Rainbow Serpent is shown travelling through countryside that has been burnt with fire. Men, represented by the U-shapes, have seen the rainbow serpent and are digging to find it. The circles represent the snake's holes.

RAINBOW DREAMING 1988

Courtesy Centre for Aboriginal Artists, Alice Springs

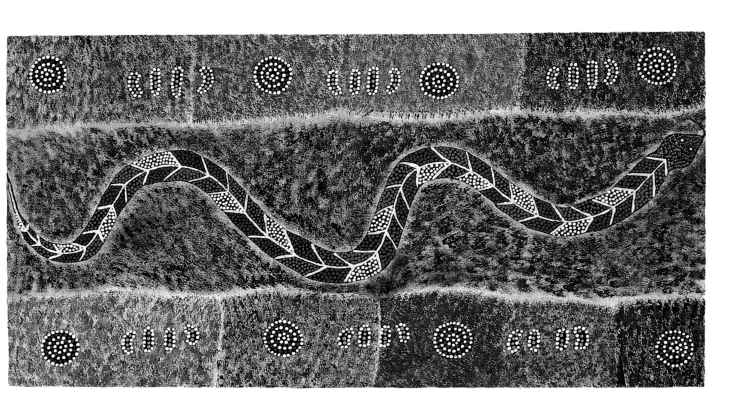

YOUNG TIMOTHY DEMPSEY

Group or Language: WARLPIRI/LURITJA
Area: PAPUNYA

The site of the spear ceremony of the Tjungurrayi and Tjapaltjarri kinship subsections is west of Yuendumu.

In the afternoon the men make camp and clear the ground in preparation. This is a ceremony where all the group participate, each understanding their role. Spears are shaped and hardened in the fire then decorated with dried leaves. The men dance from the outer camps where they have been decorating themselves with body paint. They move towards the cleared ceremonial site where the women are seated, singing the song cycles that accompany this ritual.

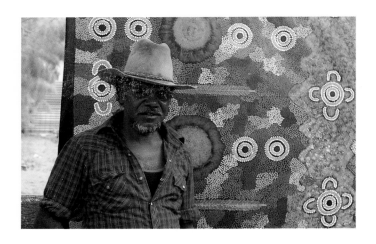

SPEAR CEREMONY 1988

Courtesy Centre for Aboriginal Artists, Alice Springs

78

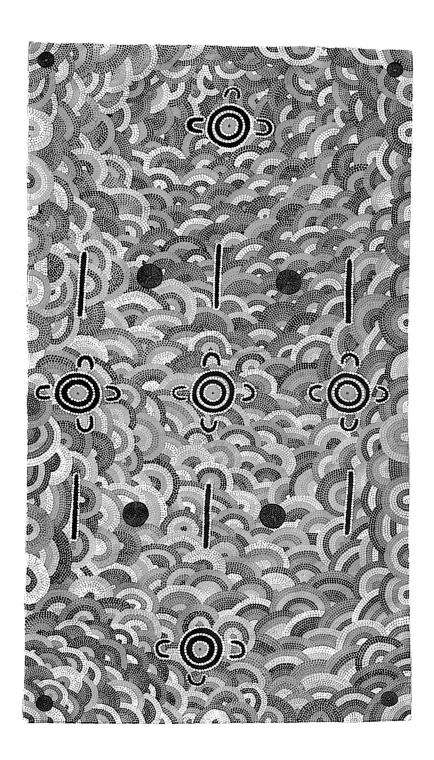

COLIN DIXON TJAPANANGA

Group or Language: WARLPIRI
Area: MT. LIEBIG

The location of this painting is the artist's grandfather's country, the far side of Yuendumu, approximately 350km north west of Alice Springs. This is an important site associated with the life-giving force of water.

The ancestor Tjangala and his people camped here leaving only to go hunting and to search for various bush foods.

WATER DREAMING 1988

Courtesy Centre for Aboriginal Artists, Alice Springs

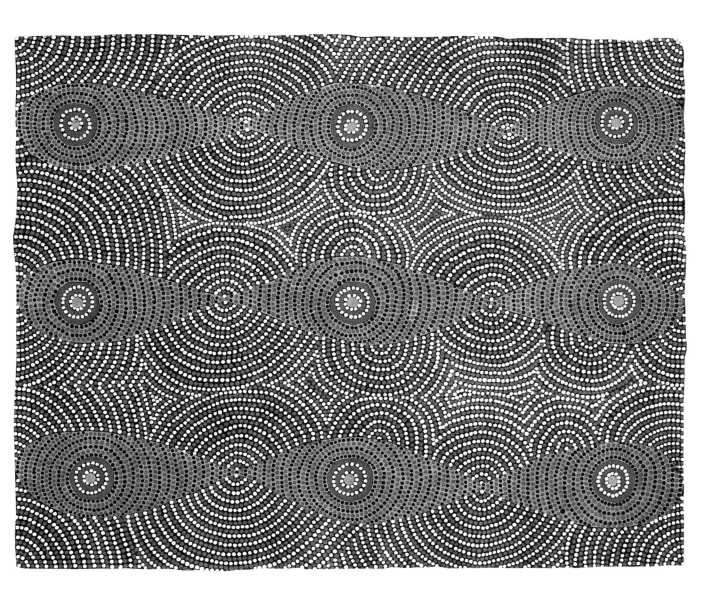

COLIN DIXON TJAPANANGA & MARY DIXON NUNGURRAYI

Group or Language: WARLPIRI
Area: MT. LIEBIG

The women, represented by the U-shapes, are shown collecting the witchetty grub from the roots of the acacia trees.

The background design represents the dreaming tracks of the witchetty ancestors during the Creation Era. Sites along this dreaming path are revisited and ceremonies and song poetry are performed there at special times of the year.

WITCHETTY GRUB DREAMING 1988

Courtesy Centre for Aboriginal Artists, Alice Springs

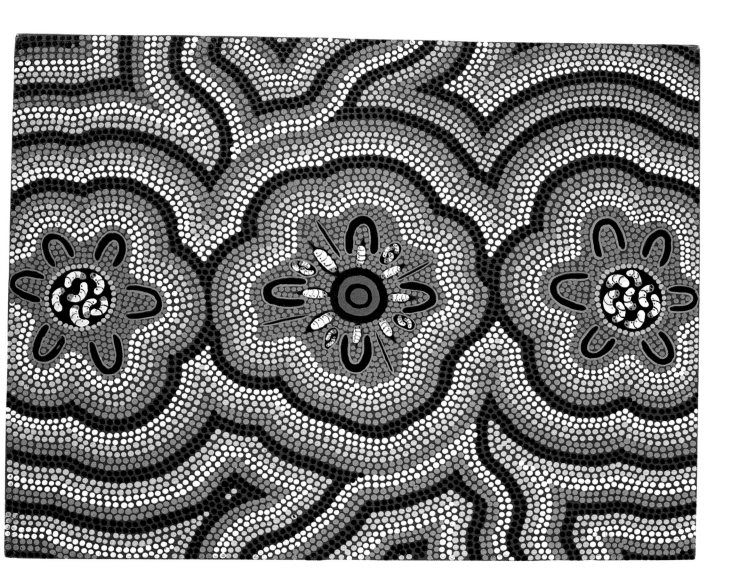

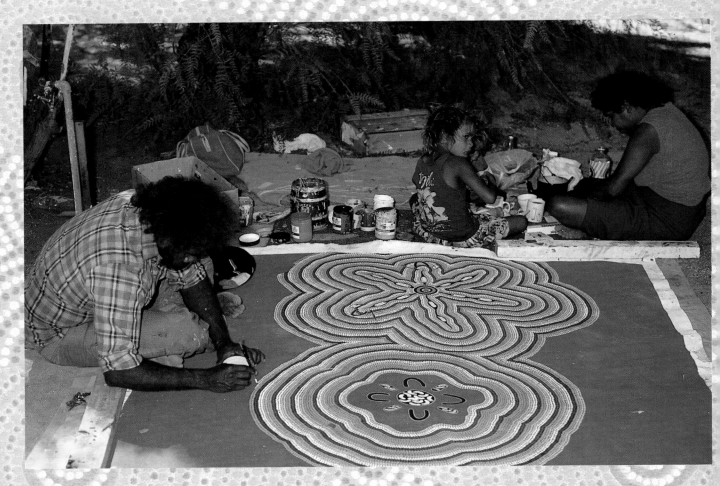

Mary and Colin Dixon work on paintings both together and separately, in the garden at the Centre for Aboriginal Artists, Alice Springs.

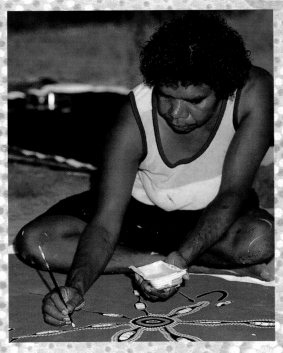

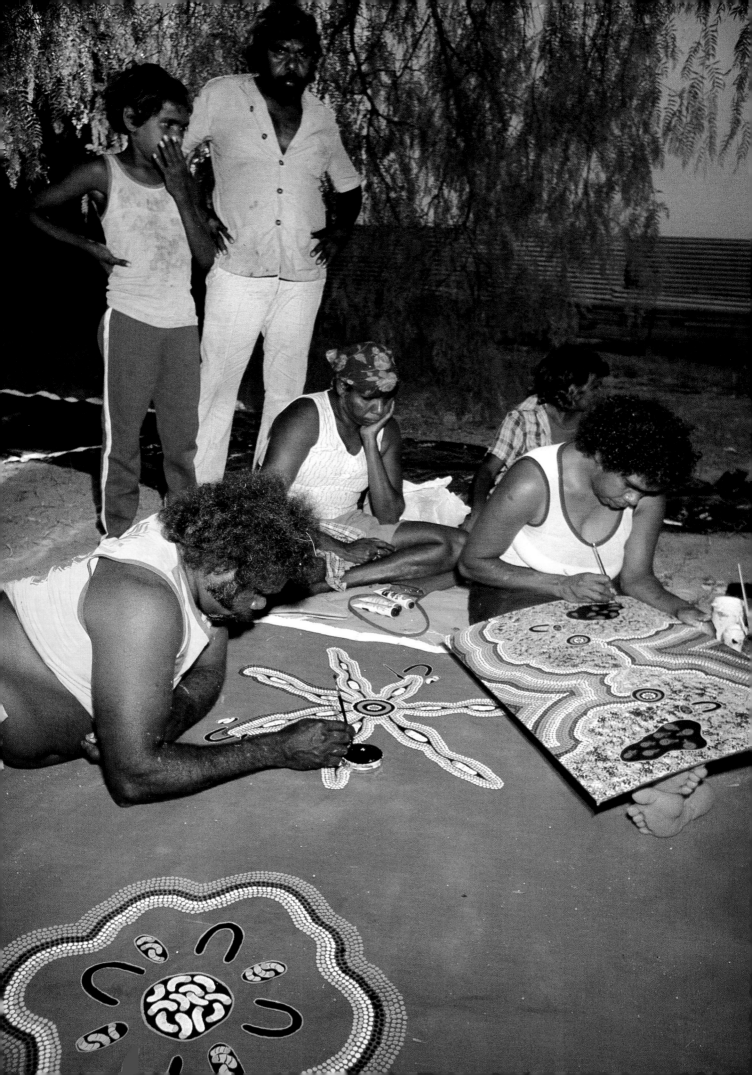

MARY DIXON NUNGURRAYI

Group or Language: WARLPIRI
Area: MT. LIEBIG

The location of this painting is Papunya, north west of Alice Springs. This is an important honey ant dreaming site.

In the central motif the hole by which the Honey Ant enters the ground is shown and honey ants are naturalistically depicted.

In the two other motifs, women of the Napaltjarri and Nungurrayi kinship subsection groups are shown digging for honey ants.

HONEY ANT DREAMING 1988

Courtesy Centre for Aboriginal Artists, Alice Springs

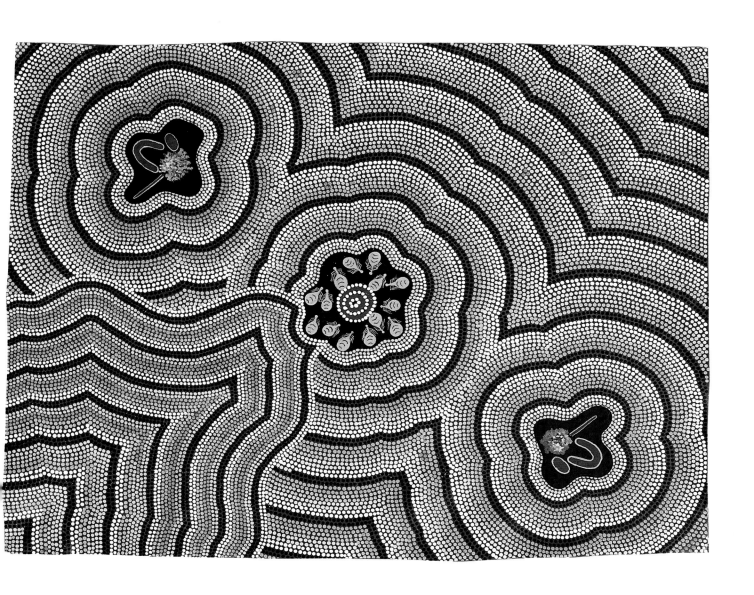

PETER LEO

Group or Language: ANMATYERRE
Area: NAPPERBY STATION

This painting tells of a men's ceremony held at Aruka (Coniston Station) approximately 180km north of Alice Springs.

At this site a large waterhole provides a permanent water supply (concentric circles). In the past people lived permanently beside this waterhole and were joined by groups from neighbouring areas in periods of drought or for ceremonies. The white dotted arc shapes represent the dreaming tracks of the ancestors and sacred ground. The long wavy lines are hairstring belts decorated with white cockatoo feathers, worn by initiated men during ceremony. The men, depicted by the U-shapes, are shown with their spears and painted shields.

Apart from the main waterhole there are several other small rockholes and soakages where animals come to drink. Here men are shown hunting with two types of boomerangs, spears and shields.

The white flowers in the background are soft stemmed native daisies which are crushed and mixed with red and yellow ochres and used in ground, body and shield decorations.

ARUKA DREAMING 1988

Courtesy Centre for Aboriginal Artists, Alice Springs

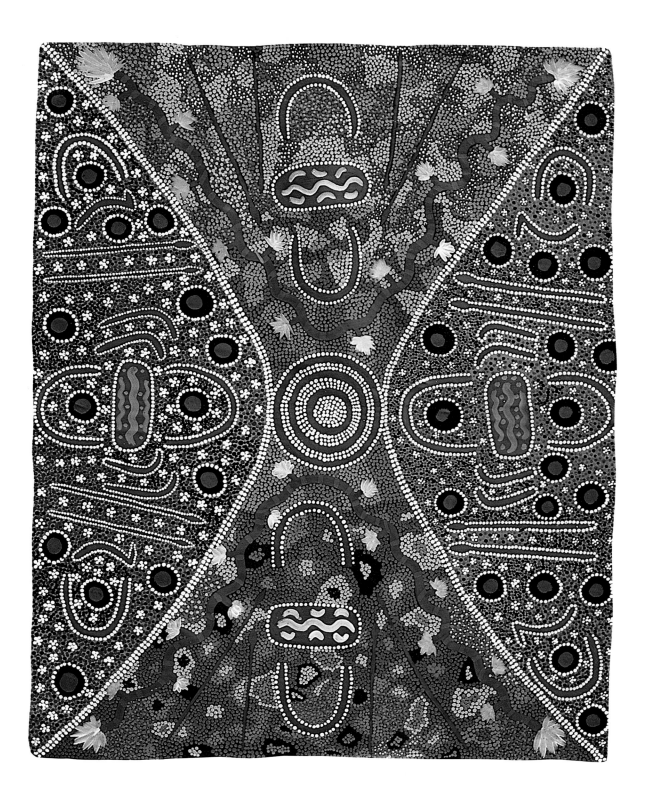

AUDREY MARTIN NAPANANGA

Group or Language: WARLPIRI
Area: ALICE SPRINGS

This is the artist's father's dreaming of Mt. Theo, near Yuendumu. Goannas are chasing small lizards and grasshoppers (Jintilyka). They catch and eat them. The concentric circles depict different entrances to the goanna burrows and the wavy lines are their underground tunnels. Goanna tracks are shown.

Audrey Martin Napananga was born at Yuendumu and was taught to paint by her sister, Netta Napananga. Her totems include bush coconut, desert tomato and wild grape.

GOANNA DREAMING 1988

Courtesy Centre for Aboriginal Artists, Alice Springs

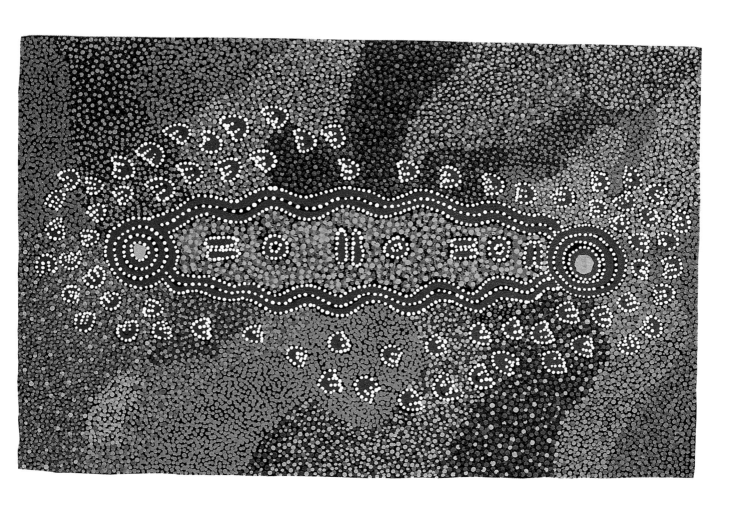

JOSEPH JURRA TJAPALTJARRI

Group or Language: PINTUPI
Area: PAPUNYA

This painting depicts designs associated with the Perentie Dreaming at the site of Kannarinya, to the south of the Kiwirrkura Community.

The roundel shows the place where the Perentie lived, the lines are sandhills and the background represents the surrounding country.

The Perentie slept at this place before travelling east to the Kintore Ranges.

PERENTIE DREAMING 1988
Courtesy Gallery Gabrielle Pizzi

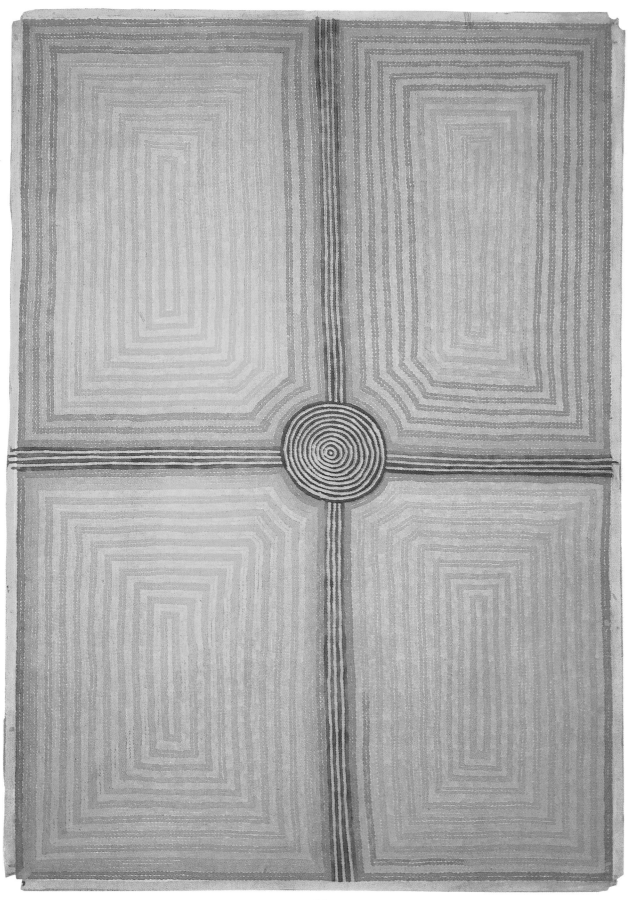

SONDA TURNER NAMPITJINPA

Group or Language: WARLPIRI
Area: MT. LIEBIG

This painting celebrates all the activities of the Women's Fire Ceremony. This dreaming belongs to the Nangala/Tjangala kinship subsection group. Here, Nangala is teaching her niece, Nampitjinpa, all aspects of the fire ceremony. When Nangala passes away it will then be the responsibility of Nampitjinpa to teach the young women of the Nangala skin group.

In the middle of the lower section of this painting, women, depicted by the U-shapes, are sitting down singing and painting a large coolamon before the ceremony. Beside them are sticks with human hair tied at the end which are used to paint their bodies with red and yellow ochres. The ochres are mixed with water and applied to their breasts and arms which have been greased with emu and kangaroo fat. The body paint designs for this particular fire ceremony are represented by the symbols in the lower half of the painting.

The concentric circles middle right are the sites where fire ceremony designs have been made on the ground. Ceremonial poles have been placed in a hole in the middle of these designs and they are attached to human string and decorated with cockatoo feathers. The yellow and white asterisk pattern also symbolises the cockatoo feathers. The spindles for making human hair strings are shown to the left.

The top three concentric circles depict the big fires that are lit in three corners of the ceremonial site at sunset ready for the dancing to take place. The smoke from these fires is the blue/grey asterisk patterns. The double dotting is the dust made by the women as they dance.

WATYA WANNU (WOMEN'S FIRE CEREMONY)
Courtesy Centre for Aboriginal Artists, Alice Springs, 1988

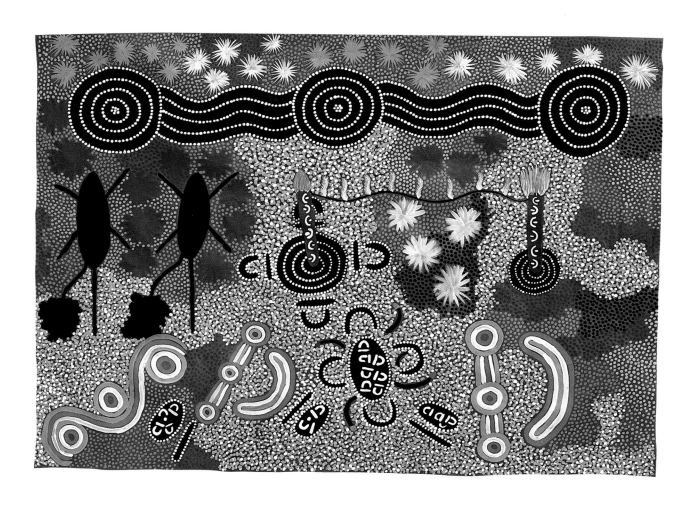

EUNICE NAPANGARDI

Group or Language: WARLPIRI
Area: PAPUNYA

The centre roundel represents the bush banana plant with its radiating vines. Around the plant some Napangardi and Napanangka women (skin subdivision names), represented by the U–shapes, are collecting the fruits with their digging sticks (straight lines) and coolamons (oval shapes). The yuparlis (bush bananas) grow in rock crevices close to dry river beds in spinifex country.

Eunice Napangardi was one of the first Aboriginal women painters at Papunya.

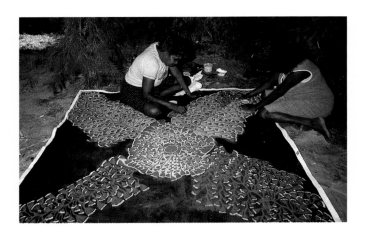

BUSH BANANA (YUPARLI) DREAMING 1988
Australian Stockman's Hall of Fame (172cm x 180cm)

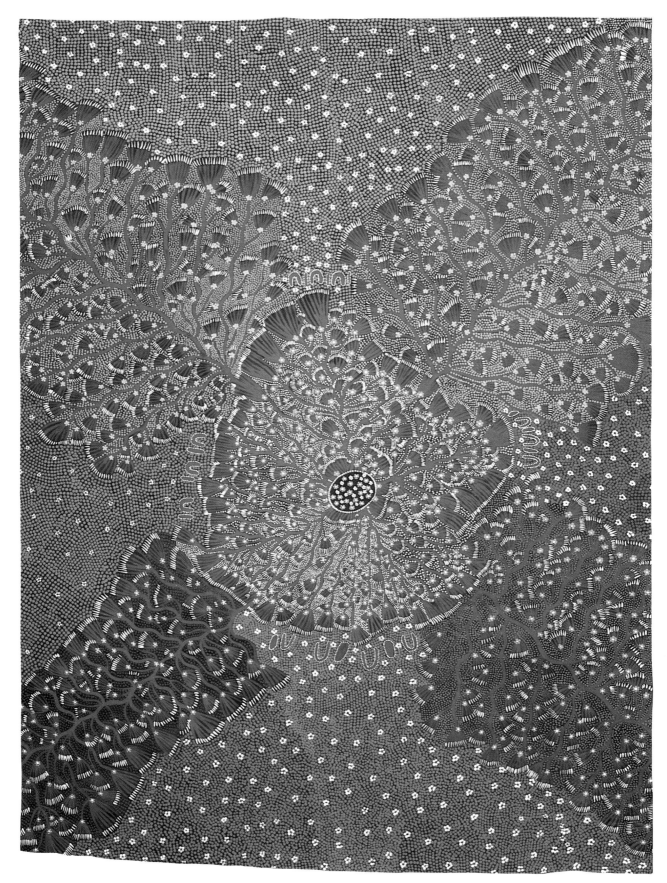

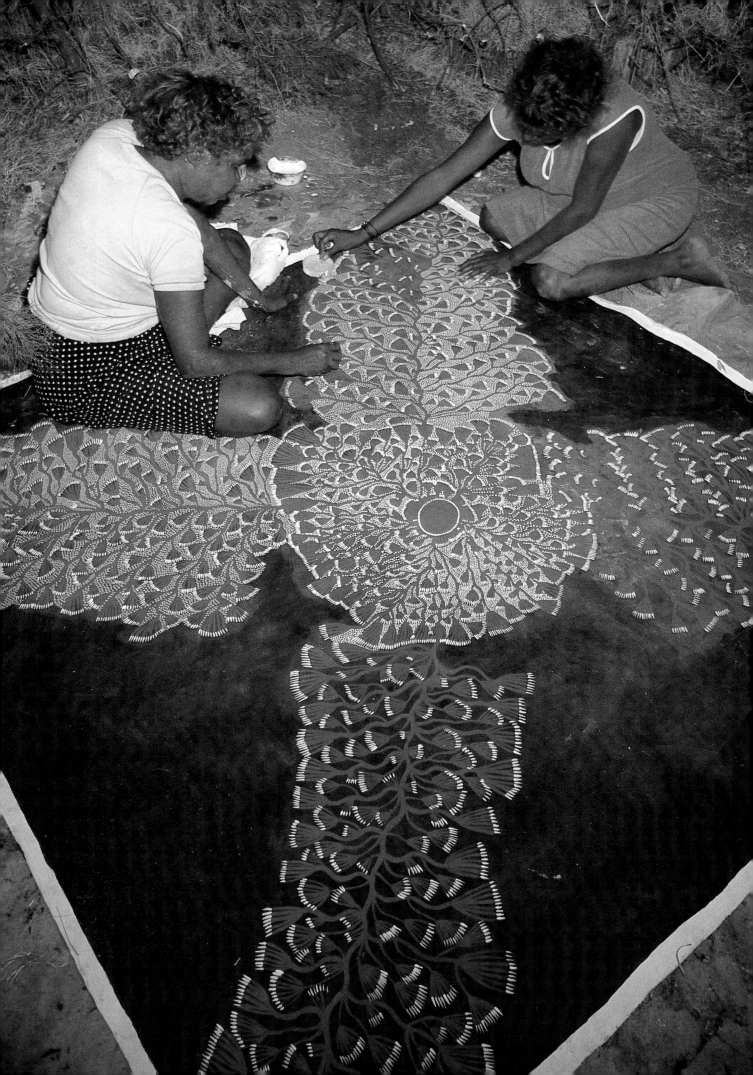

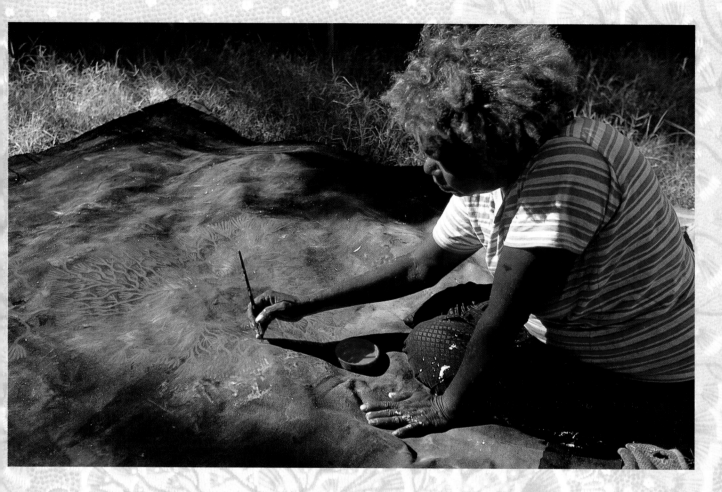

Eunice Napangardi and one of her relatives work on a painting of the Bush Banana Dreaming (Page 97)

DINNY NOLAN TJAMPITJINPA

Group or Language: WARLPIRI AND ANMATYERRE
Area: PAPUNYA

In this painting two dreamings associated with the site of Yarbidji are depicted. The concentric circle represents a cave at the site connected with both the witchetty grub dreaming and the willy willy Dreaming.

The witchetty ancestor travelled from Yarlukarn underground and emerged at Yarbidji. The short wavy lines depict the witchetty. The 'willy willy' wind Ancestor, a Tjangala, was sitting in the cave all the time. He was not travelling. He is depicted by the long sinuous lines. The straight lines are windbreaks. All these motifs are used as body paint designs during these ceremonies.

WITCHETTY GRUB AND WILLY WILLY 1988
Courtesy Centre for Aboriginal Artists, Alice Springs

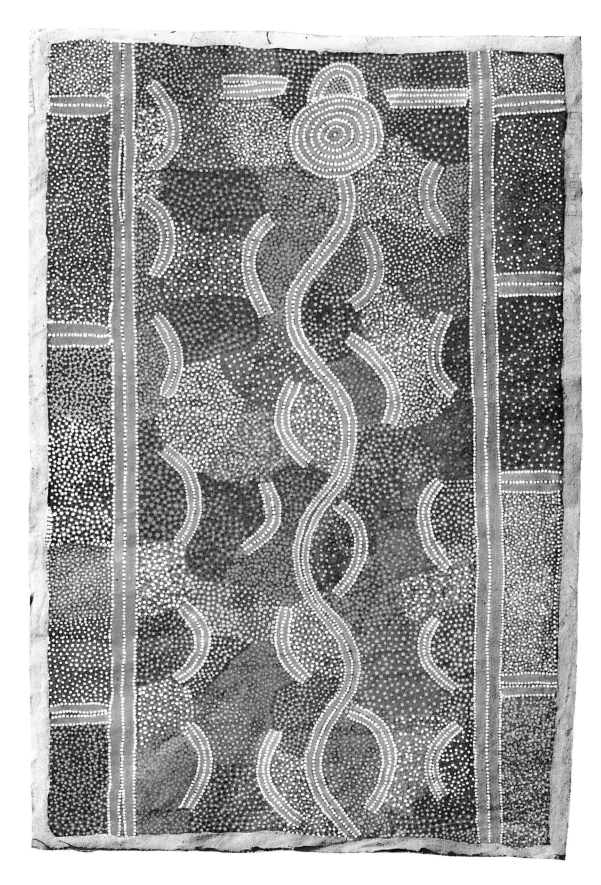

SIMON TJAKAMARRA

Group or Language: PINTUPI
Area: PAPUNYA

This painting concerns three small, non-venomous snakes called Nyua — a father and his two sons — at a big waterhole southwest of Kintore.

The central roundel is this waterhole, Tjuntina. The border roundels are also waterholes.

SNAKES AT WATERHOLES 1986

Courtesy Gallery Gabrielle Pizzi

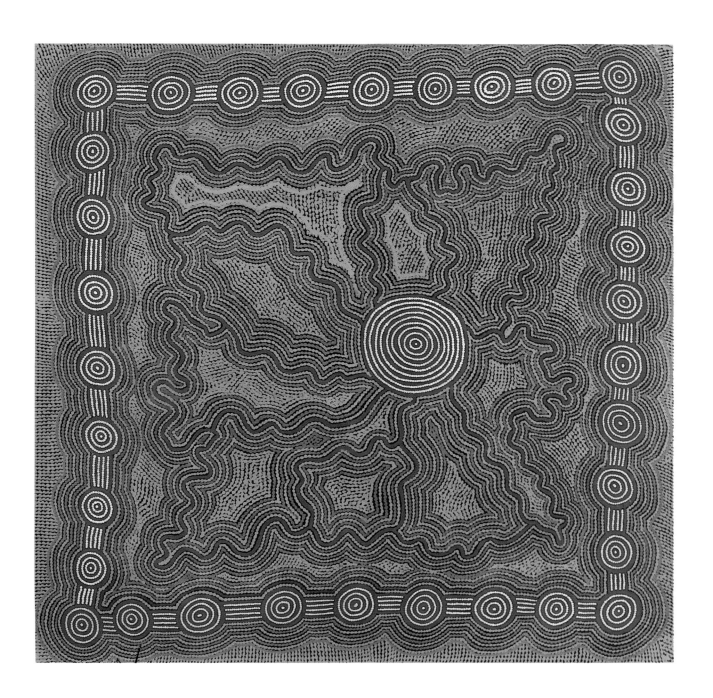

Rene Robinson Napangardi

Group or Language: WARLPIRI
Area: YUENDUMU/ALICE SPRINGS

The artist's father, Tjapananga, is the senior custodian of this Brown Snake Dreaming story which took place at Vaughan Springs, near Yuendumu.

The snake on the right hand side is a female snake who is being woken by the male.

BROWN SNAKE DREAMING 1988

Courtesy Centre for Aboriginal Artists, Alice Springs

104

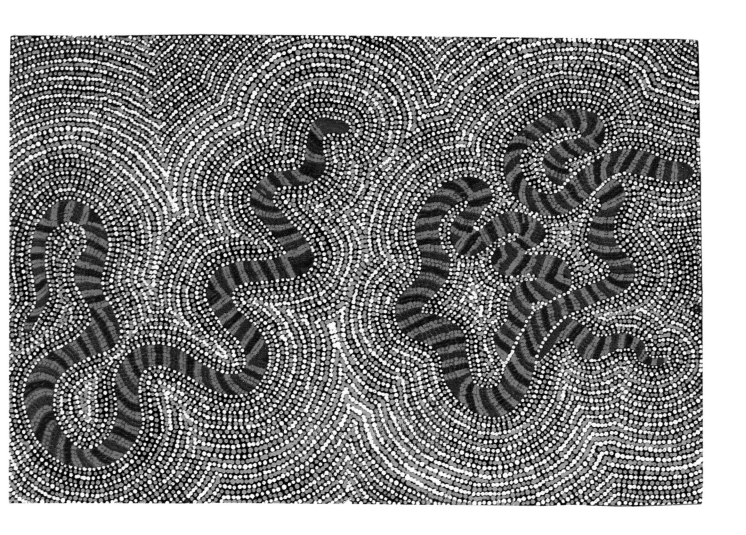

WENTON RUBUNTJA

Group or Language: ARRERNTE (ARANDA)
Area: ALICE SPRINGS

These are men's body paint designs worn on the forehead and stomach during ceremonies. These designs are a protection from lightning.

During the Creation Era a big rain came to Yamba Station, near Vaughan Springs (concentric circles) washing people away. Severe lightning hit the rockholes. The lines adjoining the circles represent rain. The central pink lines depict lightning and the white patterning symbolises clouds.

Wenton Rubuntja is a senior custodian of the Aranda Tribe and one of the traditional owners of the land around Alice Springs. He was previously chairman of the Central Lands Council.

THUNDERSTORM DREAMING 1988

Courtesy Centre for Aboriginal Artists, Alice Springs

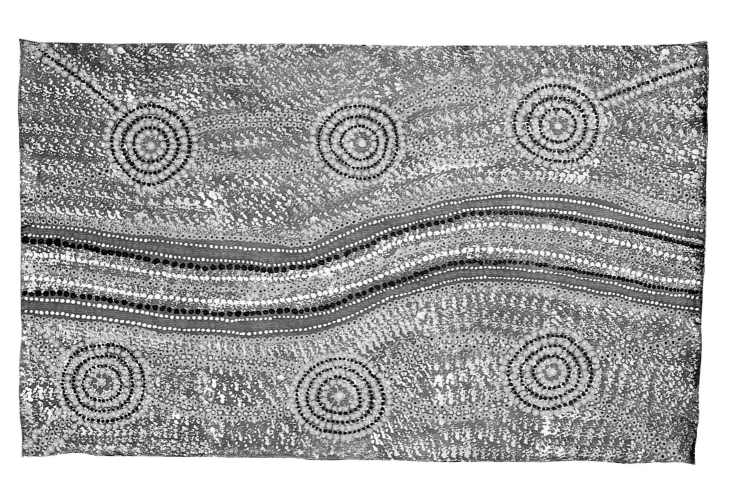

ANATJARI TJAMPITJINPA

Group or Language: PINTUPI
Area: PAPUNYA

This painting depicts designs associated with the secret-sacred Tingari ceremonies at the site of Tjulnya to the south-east of the Kiwirrkurra Community. Because of the secret nature of these ceremonies, no further detail was given.

Generally, the Tingari are a group of mythical characters of the Dreaming, who travelled over vast stretches of the country, performing rituals and creating and shaping particular sites. The Tingari men were usually followed by Tingari women and accompanied by novices and their travels and adventures are enshrined in a number of song cycles. These mythologies form part of the teachings of the post initiate youths today as well as providing explanations for contemporary customs.

TINGARI CEREMONIES AT TJULNYA 1987

Courtesy Gallery Gabrielle Pizzi

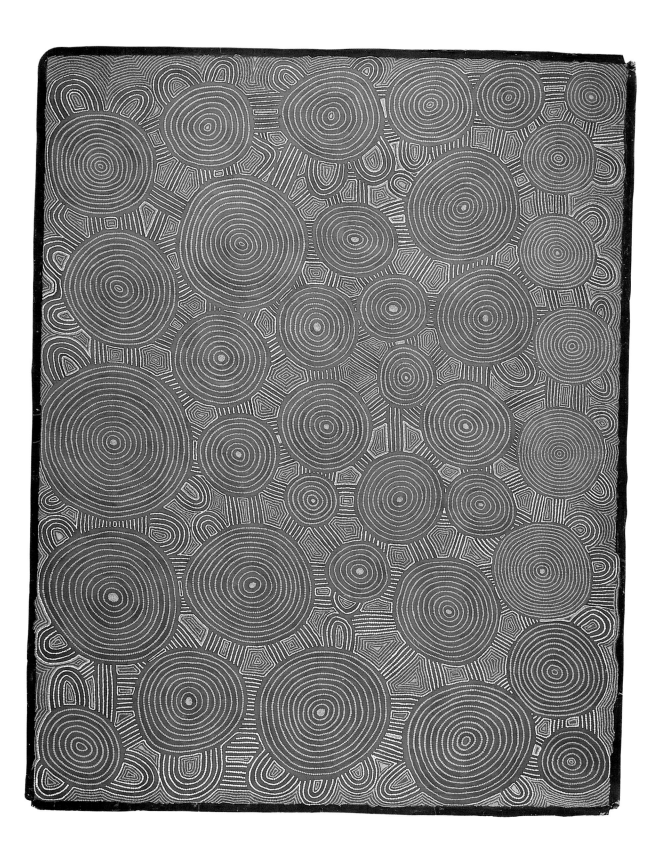

KAAPA TJAMPITJINPA

Group or Language: WARLPIRI-ANMATYERRE
Area: PAPUNYA

This emu is travelling through Snake Country looking for food which is depicted by the white dots. This country, called Mikanji, west of Yuendumu, is also an important water dreaming site and many ceremonies take place at its permanent waterhole.

The concentric circles represent this waterhole and the arc shape at the top represents the custodian of the dreaming.

The artist, one of the elders and first painters of the Papunya area, has won major national art awards.

EMU DREAMING 1988

Courtesy Centre for Aboriginal Artists, Alice Springs

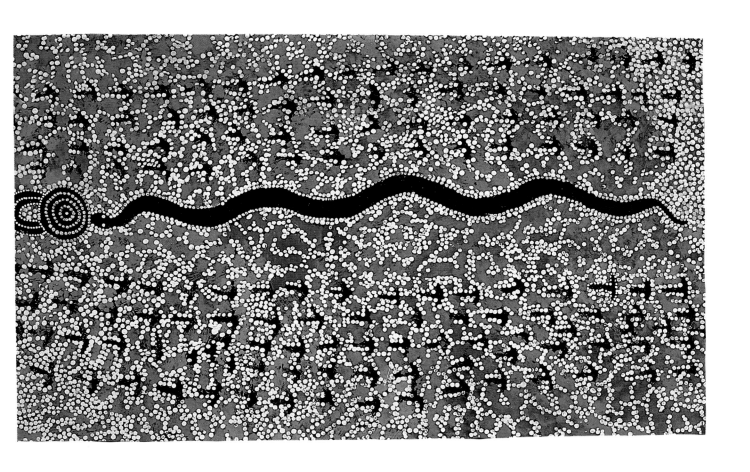

Kaapa Tjampitjinpa

Group or Language: WARLPIRI-ANMATYERRE
Area: PAPUNYA

At the water-dreaming site of Mikantji, west of Yuendumu, a group of men are seated around a fire telling stories. The sinuous lines represent running water and the small circles are hailstones which relate to the story of how this water site was created.

Kaapa Tjampitjinpa is one of the founding elders of Papunya-Tula.

WATER DREAMING 1988

Courtesy Centre for Aboriginal Artists, Alice Springs

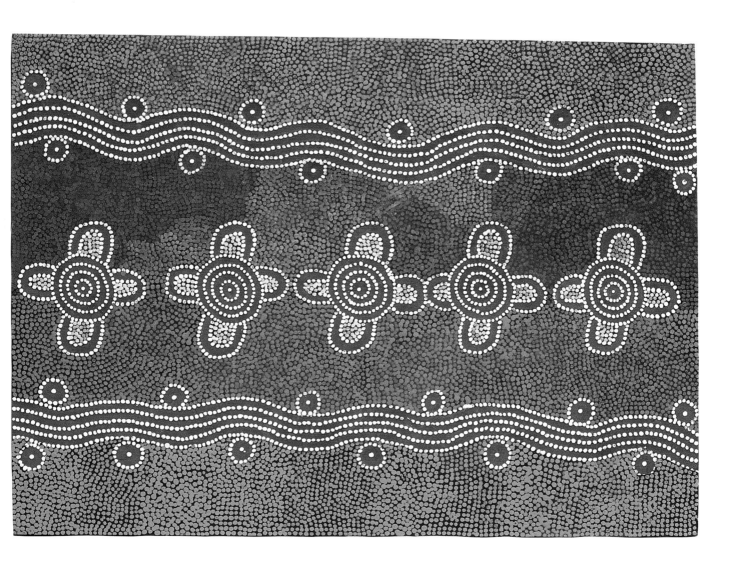

BROGAS TJAPANARDI

Group or Language: WARLPIRI
Area: RED SANDHILL

This painting concerns a witchetty grub that changed into a snake at the site of Kunatjari, west of Yuendumu. This is the artist's father's country. The central concentric circles represent the sacred site where ceremonies for this dreaming take place during a young man's initiation.

The concentric circles on either side of the centre are waterholes where the snake lives. Snake tracks and small snakes are also shown. The four concentric circles in each corner symbolise acacia trees where women are digging for witchetty grubs.

SNAKE AND WITCHETTY GRUB DREAMING 1988
Courtesy Centre for Aboriginal Artists, Alice Springs

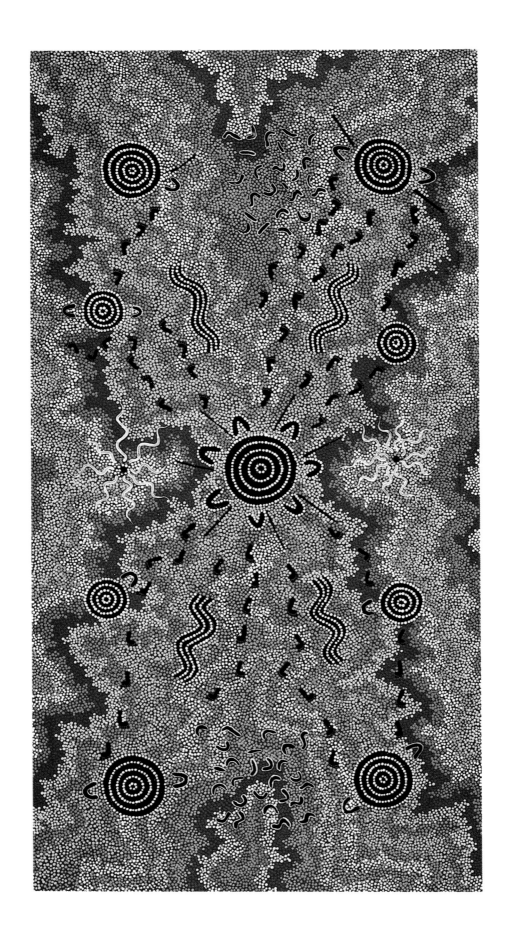

Rahel Ungwanaka

Group or Language: ARRENTE
Area: RED SANDHILL, HERMANNSBERG

This painting celebrates several different Dreaming stories associated with the site of Ellery Creek, towards Hermannsberg, the artist's grandfather's country. The bottom section traces the travels of a small striped fish from Ellery Creek to Old Station. Each site that the fish came to is marked by concentric circles and these sites remain the borders of the land of the traditional owners. Rahel's grandfather's Aranda name means 'striped', reminding us that he is the custodian of the Dreaming for these small striped fish.

The middle section depicts the travels of the Honey Ant Ancestor from Ellery Creek to Old Station, through Salt Hole to Red Sandhill, the outstation where Rahel, the artist, and her husband, Nahassan, live. The concentric circles are the sites and the women are shown as U-shapes with their digging sticks and coolamons collecting the honey ants. The small arc shapes above symbolise the bark of the white gum tree, 'Lyabra'.

The top section of the painting is Black Cherry dreaming, known in Aranda as 'Lalija'. It is a bush food with black skin, soft flesh and a small stone, *Santalum lanceolatum*.

ELLERY CREEK DREAMING 1988

Courtesy Centre for Aboriginal Artists, Alice Springs

116

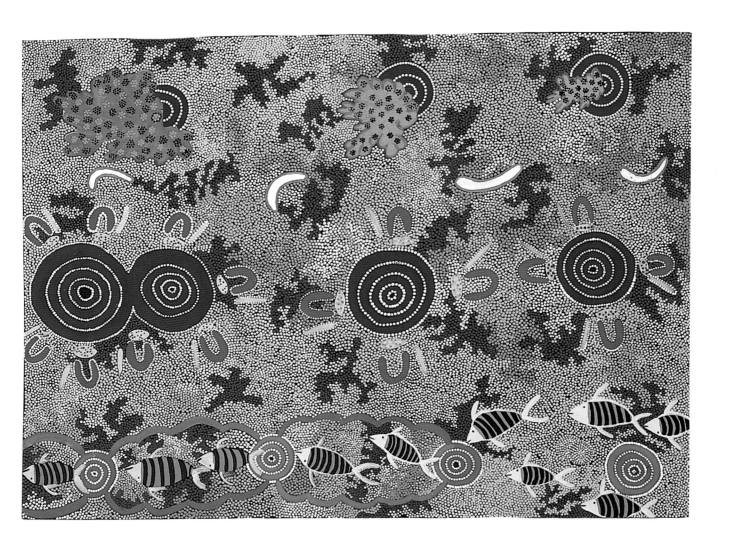

PAULINE WOODS NAKAMARRA

Group or Language: WARLPIRI
Area: YUENDUMU/ALICE SPRINGS

In diagonal corners of this painting a woman is shown with her coolamon. One is of the kinship subsection group Naparulla and the other is Nakamarra — auntie and niece. They are travelling towards their meeting place, near Yuendumu, approximately 350km north west of Alice Springs.

This site is depicted by the central concentric circles. When the women meet they dig for yala (desert yam).

YALA DREAMING 1988

Courtesy Centre for Aboriginal Artists, Alice Springs

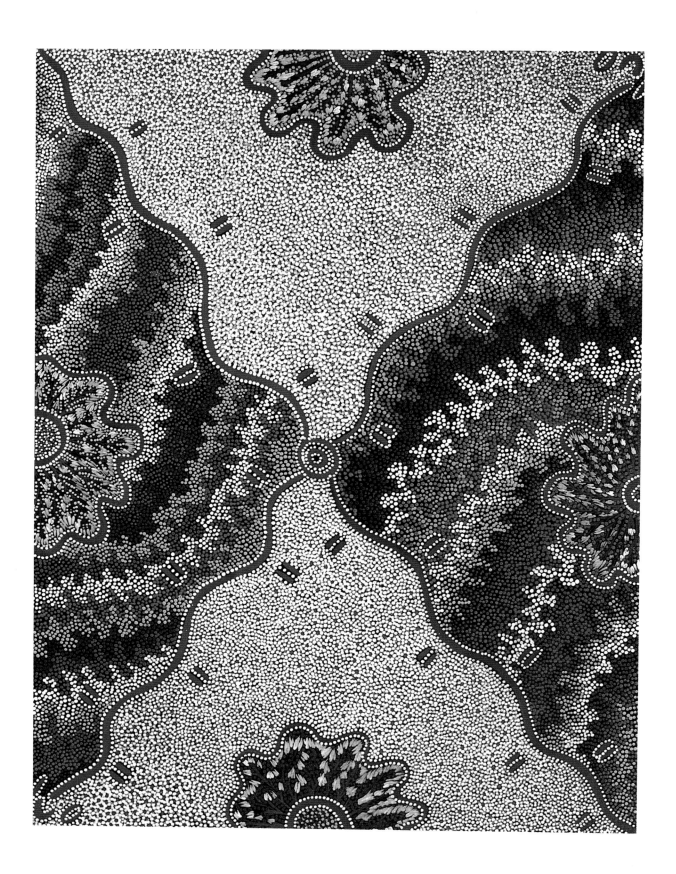

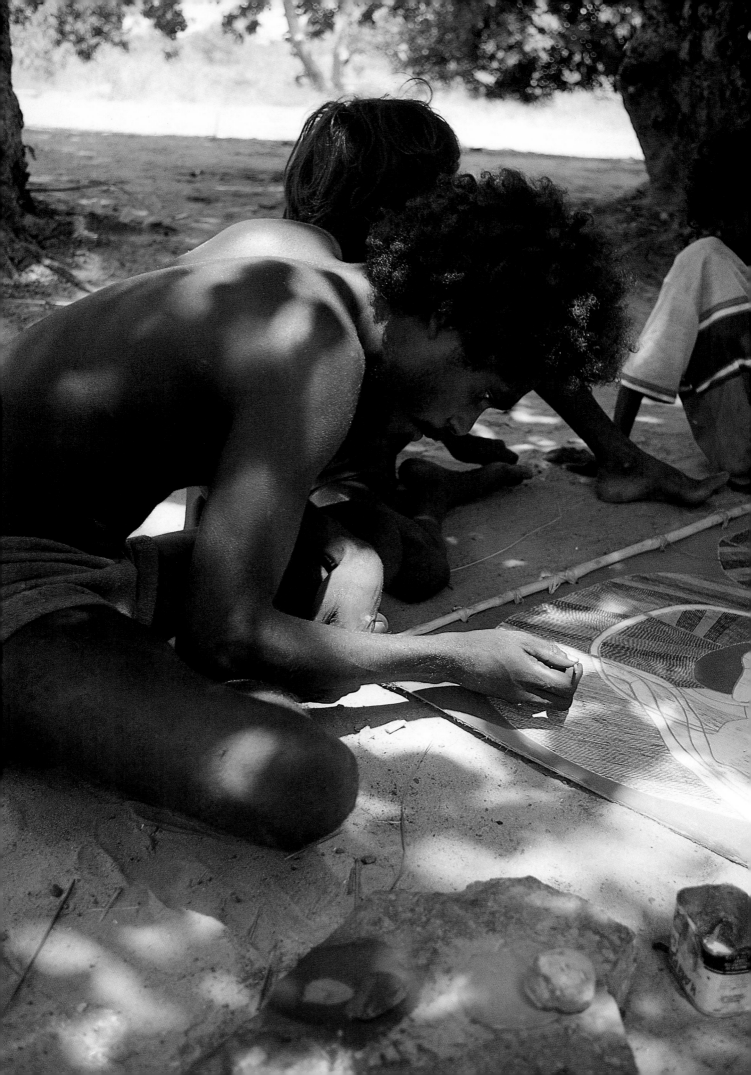

BARK PAINTINGS OF ARNHEM LAND

Until the advent of desert canvas paintings, bark paintings were the most distinctive and well known form of Aboriginal visual art.

Throughout the tropical 'top-end' of the Northern Territory of Australia, Aboriginal artists still use natural ochres and human hair brushes to create fine, mesmerising patterns. These ceremonial designs or ancestral images are all painted on strips of bark as well as on the bodies of dancers and on a variety of other surfaces.

It is not as easy to ascribe ancient origin to the symbols used in the paintings of the north as it is for the people of the centre. The most obvious links to extreme antiquity in art occur in the paintings of western Arnhem Land which, both in the subjects depicted and in the style, are closely allied to the ancient rock paintings of the escarpment area and Kakadu National Park. It is clear that the mythology of the great ancestors, particularly the Rainbow Serpent, extends back in antiquity here to possibly 20 000 years ago.

The actual origin of the practice of painting on bark can not be accurately determined although it is clear, both from references in journals and early writings of nineteenth century observers, that Aborigines were painting on bark at least in the mid-nineteenth century. An exhibition of Australian ethnographic objects included bark paintings as early as 1879.[1] In the south east of the continent paintings were once executed on the inside surfaces of bark houses and this was also the custom in the north until recent times.

The majority of contemporary bark paintings are produced in the remote area of the country known as Arnhem Land. This is an 80 000 kilometre reserve that stretches from the Alligator River 150 kilometres east of Darwin to the coast of the Gulf of Carpentaria. Although the area now includes mining leases and a section of Kakadu National Park, it remains also the homeland of thousands of Aboriginal people who follow traditional life styles and maintain the ceremonial laws of their

In the dappled shade of large trees, Arnhem Land painters make intricate paintings using natural barks, ochres and brushes from human hair.

Creation ancestors. Here, paintings are of the land and its creation. The stories are told more literally in paintings than in desert designs with images clearly depicting human figures, mythological ancestors in multiple guises: half man, half animal, half crocodile, half snake. There are also stylised images of fish, animals and birds as well as their symbolic counterparts. This is a totally different visual culture.

The people of the north, like those of the desert, have increasingly formed satellite communities out from their main settlements, many of which are from 50 to 300 kilometres away from the nearest supply depots and must be serviced by truck, boat or plane, depending on the season. The production of portable and saleable community art has, therefore, become a significant component in the economy of many remote out-stations. In this context bark paintings are by far the most important works of art.

While the desert people consider that the ancestors of the sacred Tjukurrpa often emerged from beneath the ground and travelled large distances from other known sites in the desert area, the beliefs and religion of the people of the north are different. In the Dreaming or Wongar times, ancestors in many different guises, created the landscape itself, however, many key beliefs relate that these ancestors either came from across the seas or from the sky. Many travelled in an east-west direction and one of the central beliefs concerns the Djankawu and Wawilak who first appeared in the country on the uppermost tip of north eastern Arnhem Land at Yelangbara. They proceeded to travel from here through to Ramingining in central Arnhem Land. The creation story continues in different forms but the lives of the two sisters who began as the Djankawu in the east extend through to western Arnhem Land where their lives become intertwined with the giant Rainbow Serpent, Ngalyod.

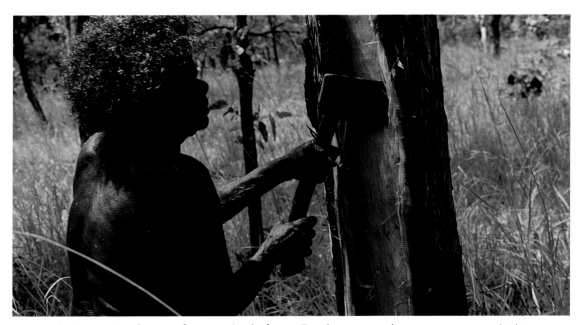

Artists strip sheets of stringybark from *Eucalyptus tetradonta* to use as painting surfaces.

122

Many other ancestors emerged from waterholes (Barama in eastern Arnhem Land) from under the ground, (Jingana, the old woman) or either appeared from or returned to the sky as natural forces such as thunder and lightning, (Jambuwal, the thunder man of the east, and Namarrkon, Lightning man of the west) or as a constellation of stars. Some of the designs of the paintings of the north-east also show evidence of the awareness and embracing of outside cultures. A particular example is the Macassens who visited the northern coast of Australia for several hundred years before white colonisation and left a legacy in language and art among the Yulngu.

In western Arnhem Land the country is rugged with ridges, rocky outcrops and plunging gorges with magnificent art galleries that date to prehistoric times. The walls and ceilings of overhanging shelters contain brilliantly coloured paintings in stylistic sequences, each overlaying the one before. Paintings include simple animal tracks, hand and weapon stencils, ancient spirit figures with hunting regalia shown in all form of action poses, and other spirit figures known as mimis, which closely resemble the contemporary bark painting mimi tradition of western Arnhem Land. The most recent rock art paintings were done in the early to mid-1960s and these are of people, spirit figures, x-ray animals and other multi-coloured, fully formed images, exemplified by the barramundi of Obiri rock in Kakadu National Park.

STRINGY BARK AND EARTH OCHRES

Aboriginal artists paint portable works almost exclusively on bark rather than canvas although new materials are starting to be used. Advisers have resisted, to date, the widespread introduction of canvas, modern paints and brushes and have continued to exhibit and organise shows of Aboriginal paintings of the north which follow the centuries old tradition of using strips of stringy bark. The style of bark paintings is still very diverse. There are no common sets of symbols which link the paintings of different areas, as in the art of the desert. Also, the ochres and colours themselves vary from region to region. The one common feature is the stringy bark itself. All communities use strips of the tall fast growing stringy bark tree *Eucalyptus tetrodonta.*

The best time to remove these strips is always the beginning of the wet season in about December. This is when the sap is rising and the bark becomes supple and easy to strip. A mature, well grown tree is selected, preferably with branches beginning well up the trunk, so that a large piece of bark can be taken. With an axe, two horizontal cuts are made around the trunk. Often a zig-zagging axe line is used for ease of cutting. A vertical cut is then made between the two horizontal cuts and the bark is prised away from the trunk using the axe or a stick as a lever. When removed, the bark comes off as a cylinder resembling the shape of the tree. The inner surface is fine and smooth, an excellent painting ground. The thinner the bark, the better and flatter the material, so the rough outer layers are removed with the axe and with knives. The sheet of bark is then placed over a fire. With the heat of the fire it immediately uncurls and when it is as flat as possible it is removed and weighted down. The moisture is driven out and with the firing the superfluous bark on the rough side is charred and is easily stripped off or cut away. For several days

the sheets of bark will be kept flat on the ground, weighted with stones, sometimes several together. In coastal communities the barks may be put underneath hot sand. Drying bark sufficiently can take from several days to a fortnight. In recent decades (since the 1950s) cross sticks have been attached and bound at either end of the strips of bark to form braces and so inhibit further movement.

The paintings are all of natural materials: earth colours, bush gum fixatives and a range of ingenious brushes which utilise twigs, sticks, human hair and combs made from palm fibre. The continued use of these natural materials has meant that the work of artists of the north has remained, in curatorial perceptions, firmly within the realm of the 'artefact' rather than 'contemporary art', possibly retarding the acceptance of these artists into the wider contemporary Australian and international art community.

The pigments used in bark paintings give this medium its unique quality and beauty. There are infinite shades of ochres and natural deposits in the Australian environment and the combination of these gives bark paintings a beauty and subtlety impossible to achieve with commercially produced paint on canvas and board. Despite their 'ethnic' or 'artefact' aspects, these works have delighted for decades and hopefully will continue to do so, despite the attraction and convenience of modern paints. The ochre colours give a gentle nature to the works. Because of the scarcity of strong, pure intense colour, special ochres have always been highly prized possessions of groups and even of individual people. In one area of western Arnhem Land a particular deposit of white is known as delek, the faeces of the Rainbow Serpent. It can only be gathered in the dry season when the Serpent is thought to be asleep. This is traded for a rich yellow obtained from the mainland opposite Elcho Island near Lake Evella. This yellow, in its natural deposit, has an association as the fat of a turtle and its colour resembles this. Because many pigments can be freely gathered in the local environment, the paintings can reflect to some extent their physical origin. However trade in colour is an ancient Aboriginal practice, not only in the north but throughout the desert where a sacred red ochre was traded from South Australia north and used in sacred men's initiation ceremonies.

In eastern Arnhem Land the two main groups into which the Yulngu, the people, are divided are the Dhuwa and Yirritja. Each own two colours. The red and white belong to the Dhuwa and the yellow and black to the Yirritja. They were exchanged between the groups but could be gathered only by the owners. In some areas the quality of the paint makes it suitable for specific uses. There are soft and wet stones, soft stones being found in river beds and easily ground into a paste. Some are more appropriate for body painting, others for barks.

The quality of irridescence is universally important to traditional people. The well known trading of pearl shell and use of quartz in magico-religious rites is an example of the value placed on the glistening and glimmering change from one colour to the other or the opalescent qualities in rocks. In many pigments and stones, particularly several found in western Arnhem Land, this quality can be seen and some artists, notably, Maralwanga, of the Gunwinggu group, use shimmering metallic oxides in paintings of the Rainbow Serpent. Such reflective qualities are thought to resemble the rainbow itself.

All pigments are usually rubbed or ground onto a hard stone palette, or, if they are already soft clay-like substances from a river bed, simply crushed and mixed with water in a small container to form a paste or slip. Such grind stones have been found in rock shelters or near ancient rock paintings in western Arnhem Land with ground-in pigment which dated to 18 000 years B.P. (before present).

Because of the flexible nature of the bark surface, the paintings tend to split and the paint to flake off. Therefore, some kind of bonding agent must be used to make the paints adhere to the bark when it moves with changes in humidity or climate. Traditional bonding agents and fixatives include stems of the *dendrobium* species of wild orchids (*Dendrobium* spp.) cut or broken in two and rubbed on the bark or on the grinding stone and mixed with the ochres. Other sources in the past were the gums and resins which exude from eucalypt trees, beeswax, and the yolk of seagull and turtle eggs. For the last few decades, due to the economic importance of selling the paintings, most communities have stocked the modern wood glue fixative, aquadhere, in their local stores or arts and craft centres. The artists mix this with the watery pigment on their grinding stones. In the 1950s it was also common to spray the surface of the barks with other commercial fixatives before sending them south. For many of the early paintings of western Arnhem Land this practice, however, has in the long term, been detrimental as faulty spraying often meant the fixative dribbled or accumulated in muddy and dark patches and chemical reactions took place in later years.

Brushes vary enormously from artist to artist. The broadly executed outer lines of western Arnhem Land paintings are more frequently made using as brushes, twigs or strips of stringy bark which have had their ends frayed by chewing. Feathers and leaf fibre were also used. The most important brushes used for the intricate cross-hatching and mesmerising grids which infill the figures on many bark paintings or cover the surfaces with geometric patterns are fine brushes of human hair up to 5cm long. Depending on the thickness of individual hairs, 2 or 3 hairs bound to a stick will form the brush. This is dipped in a fairly thick slurry of ochre and then, with the hairs pointed towards the artist, it is laid on the bark in the appropriate place and drawn across it and away from the artist, to form a very fine line. Highly skilled artists can fill the surface with lightly applied parallel lines of even ochre grids.

THE CREATION ANCESTORS OF THE YULNGU

As many of the ancestral journeys and ancient Aboriginal trade routes pass from east to west it seems appropriate to consider the art of eastern Arnhem Land first. In the east the Aboriginal people collectively call themselves Yulngu which translates simply as 'the people'. Everyone else is Balanda, an Indonesian word which comes from the Macassans. In eastern Arnhem Land ceremonial life provides the main avenues for art. The close relationship of the people to their land and their ancestors is expressed principally in the painted images on the bodies of ceremonial dancers and on the lids or surfaces of coffins during funeral ceremonies. These paintings or designs form the central element of Yulngu arts: sets of religious patterns and symbols owned by clans. The designs express the clans' descent from

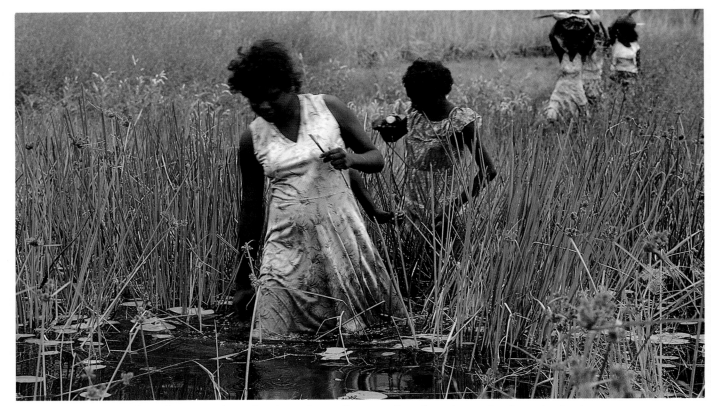

Food, craft materials and painters' supplies are all gathered on trips into the bush from outstations in Arnhem Land.

ancestral heroes and many Aboriginal people regard them essentially as title deeds. The fact that they have been passed from generation to generation and that this knowledge is needed before assuming authority in clan affairs is self-evident to the Yulngu. There are also rules about who can paint the designs and the context in which they can be shown.

As with all Aboriginal art, the designs express the Dreaming, telling great stories of the formation of the land and the creation of life by the ancestral beings. In the east these ancestors include the Djankawu, Barama and Laintjung, the Wawilak Sisters, the Honey Ancestors, Gurrumurringu and many other animal ancestors associated with these figures including Minala the tortoise, Baru the shark, and the sacred crocodile who stole the fire. These ancestors can still act to influence modern life and ceremonial performances continuously bringing the living into contact with their power.

The ancestors gave the designs, songs and associated ritual to Yulngu by performing them in creation times. For example the shark ancestor of the Djapu clan travelled from the sea to Wulwulwuy where he became a tree that still stands. The activities of the shark not only form the subject of Djapu paintings and ceremonies, but their own homeland's housing plan is based on the shape of the shark. Each member is related to a part of the shark's body, the leader at the head and others at the tail and fins.

126

The main Dhalwangu clan centre is at Gangan where the ancestor of the Yirritja, Barama, first appeared. Paintings by Dhalwangu artists illustrate the river at Gangan as well as the freshwater tortoise Minala and crayfish. The diamond motif prevalent in these paintings represents the pattern made by the reeds on Minala's back as she swam. Similarly, Manggalili clan paintings represent topographical features of Djarrakpi, their homeland centre. Such paintings may contain a lot of mythological information or comprise only one segment of the story. To the artists, the whole story is summoned to mind by even a single appropriate image.

THE DJANKAWU

The Riratjingu homelands centre at Yelangbara is the beach on which the Djankawu ancestors of the Dhuwa clans first landed when they came by canoe from Baralku. There were three of them — Djankawu himself, the elder sister Bildiwuwiju, who had already borne children, and the younger sister Maralaidj. They paddled to the wide beach at Yelangbara, singing, and the waves carried their canoe to the shallows, where it changed into a rock. Djankawu plunged his *djuta* or sacred walking stick into the sand; water appeared and a well was formed. His *djuta* is now a sacred tree. They heard the cry of the black cockatoo and then, glancing at the sandhills, they saw the tracks of a goanna and Djankawu named it djunda. They left many children there and then travelled on to Bilirri, Borkinya and Ganungyala. At Bilirri, Djankawu saw the sun rise over the hill, spreading its rays across the sky. (Bilirri means 'the spreading rays of the sun'.) Djankawu named the places he saw and all the animals they found. At Borkinya he named the wild turkey, and at Ganungyala he stayed until dawn and saw the morning star. All these places are in the country of the Riratjingu people.

THE WAWILAK SISTERS

The Wawilak sisters are also the subject of numerous bark paintings incorporating snakes, waterholes and other animals and plant forms associated with waterholes.

The Wawilak sisters travelled over the land from east to west, giving names to birds, animals, plants and fish. When the younger woman was about to give birth, they camped beside a clear waterhole in which the Rainbow Serpent lived. After the sisters had made a shade from stringy bark, the baby was born. As the older sister went to collect paperbark in which to cradle the baby she accidentally polluted the waterhole with blood. The serpent was very angry and, rising into the sky as a rainbow, he made a thunderstorm and caused a storm of lightning, rain and thunder. Then he devoured the women and the newborn baby.

Other variations of this story recall how animals collected by the women on their journeys leapt out of their dilly bag at certain points and jumped into the waterhole. Many of these can be seen in some of the paintings of central Arnhem Land communities.

In an extension of the story and as a symbol of rebirth, the snake later regurgitated the women on an ant nest. They were brought to life through the numerous ant bites inflicted on their bodies.

THE CONTEXT OF PAINTING

Death is an extremely important event. Mortuary ceremonies call all relatives together for periods of many weeks. The song cycles and dances performed recall the history of the totemic ancestors of the deceased and send the spirit of the dead on a journey to the land of the spirits. The designs are owned by clans, not by individuals. In north east Arnhem Land the Yulngu consist of many different language groups of which all are broadly divided into two segments, the Yirritja and the Dhuwa, similar to the eastern philosophy of Yin and Yang. This division extends to all substance in the cosmos: animals, plants, fire, water, etc. Those born into the Yirritja group must marry Dhuwa and vice versa. The origin of each is quite separate, all the descendants of the Djankawu, for example, being Dhuwa and all descendants of Barama or Laintjung being Yirritja.

Within the Dhuwa and the Yirritja, each clan has its own dreamings and mythological origins, and its own symbols to express this.

The bark paintings done today are directly related to the most finely detailed clan designs which were always executed as body paintings and hollow log coffin paintings. Every line and mark within the design has symbolic meaning. The symbols must be learnt along with the complex detail of song cycles which gives the meanings of the designs. These meanings are conveyed to young men and women by degree according to their status. It is only on full maturity that the deepest knowledge of the clan and the multiple levels of symbol through to its 'inner' meaning are revealed. The objects themselves may perish but the designs live in the memories of the clan. As with all oral histories subtle changes occur from generation to generation as each artist brings to their work their own personal vision and interpretation.

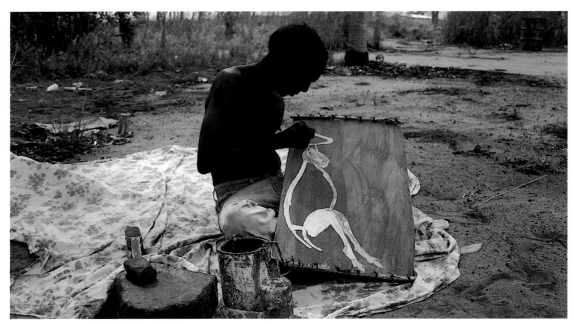

Jimmy Galereya, Gunwinggu bark painter of western Arnhem Land.

Northern Aboriginal artists work in family groups, so that sons, daughters and other relatives see the barks as they are being painted and hear the meaning. The increasing economic importance of bark paintings has meant that children have added opportunities to learn and practice their arts and, therefore, understand the meaning of the landscape around them, although they may live in more settled communities than in the past.

Subjects vary according to the pre-occupation of the artists at the time so that in the west they may concern thunder dreamings, rain, water, procreation of the species or the major stories of the Kunapipi rituals which bring on the wet season. (The Kunapipi rituals are associated with the Rainbow Serpent itself. They are fertility ceremonies designed to ensure the procreation of all species through a good wet season.)

In eastern Arnhem Land today it is almost as common for women to paint on bark as for men. In the 1960s an artist might sketch an outline of the design which would then be left for filling in by family members, often daughters or wives. However today women's paintings are an important part of the cash economy. Daughters of great older artists are entrusted with full sacred paintings which are in no way diminished in their subject matter, although their slant must always be appropriate to women's roles so that separate, secret men's subjects are retained by the young men. When artists sell bark paintings they usually provide 'a brief story' with the work. This generally consists of a simple explanation of the designs, as would be told to very young children in the community. In common with artists of the desert, the deeper levels of meaning, or actual references to sacred symbols depicted, would be reserved as knowledge only appropriate to tribal elders with ritual maturity.

Many choose to visually explore only the peripheral aspects of sacred stories of which there is no danger of disclosure. These paintings become 'designed' in a very contemporary way unlike the static but more information-dense religious painting of their forebears. Thus in his early works the artist Milpurrurru frequently painted sacred waterholes, sacred stones or ritual emblems in among various animals and plant forms at sacred waterholes. His increasing painterly skill and vision, and the knowledge that the art buying public was interested primarily in dexterity, flamboyance, colour, line and technique meant that the necessity to include more ritual 'meaning' in art, to be sold diminished. The artist retained these subjects for the ritual context — on coffins, bone poles or the bodies of dancers.

WESTERN ARNHEM LAND ARTISTS

In the west of Arnhem Land among the Gunwinggu and associated peoples, and the inland Rembarrnga, the bark paintings relate more closely to the style of ancient cave art. Here, during the long wet season when the rivers overflowed, Aboriginal families retreated to higher ground and camped in sandstone shelters where they created innumerable ochre paintings. These provide a magnificent historical record of the continuous occupation of the area by successive generations for possibly 30 000 years. Early bark paintings of the twentieth century are very similar in impact to the cave art. In newer examples however, a greater degree of

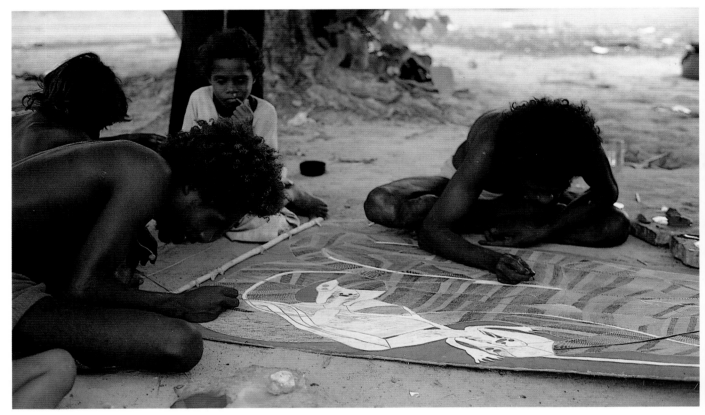

In western Arnhem Land, James Iyuna paints with his brother, John Mowunjal, watched closely by the children.

precision in execution and minuteness of detail has emerged. The barks are prepared perfectly and fine lines, even finer than those of eastern Arnhem Land, are painted over the entire surface of figures. The simple yet bold patterning of old paintings has been replaced by complex and elaborate cross-hatching.

In western Arnhem Land lengthy sacred ceremonies recall the events of the Dreaming with a central ancestor being Ngalyod, the Rainbow Serpent. Other important characters include Luma-Luma, the giant and several spirit kangaroos and wallabies of particular sites known by different names: Kolobar, Kalkberd and Kandakid.

The Rainbow Serpent is extremely significant throughout Australia and occurs frequently in bark paintings in many manifestations. It is usually represented in snake form with a characteristic composite head which might include kangaroo ears, crocodile snout and teeth as well as a feathery 'antler-like' extension. In many versions of the mythology this symbol is said to assist the serpent in travelling underground. Ngalyod also protects sacred sites and inhabits certain waterholes. Sometimes the body resembles a crocodile or an adder. One interpretation of the antler features of the serpent is that it represents the head-dress of black cockatoo feathers worn in Rainbow Serpent ceremonies. The serpent is frequently associated with sacred billabongs and lagoons where water lilies on the surface indicate the

presence. In the wet season Ngalyod appears in the sky as a rainbow and sometimes has a fish tail with fins or water lilies along the back. A key role of the serpent is as an agent of punishment and destruction and therefore the keeper of the law; children are told that Ngalyod will rise or swallow them if they break important rules or customs.

The escarpment region is rocky and precipitious and has been fully investigated by only few white people. In particular, the explorer and artist, George Chaloupka, has found and mapped numerous sites in western Arnhem Land of cave paintings in this escarpment area. Only two are readily accessible to the public: Obiri Rock and Nourlangie Rock in the Kakadu National Park. As tourism develops however, and as Aboriginal communities now have increasing control of their own affairs in this regard others may well be open in future.

Like the beautiful rock paintings the bark paintings also record aspects of myths which tell of the actions of mischievious mimi spirits. These spirits are thought to have taught Aboriginal people many techniques, particularly for hunting. They are also considered to be the ancient artists who painted the thin red ochre rock paintings thought to be 20 000 years old.

Many Gunwinggu artists paint images of Mimi hunters spearing kangaroos. Nguleingulei once told the story of a Mimi who lived in a cave and used to paint on rocks. One day he decided to go hunting for kangaroo. So he drew a kangaroo on a rock and then went out hunting. After spearing one he followed the drops of blood, then found it and carried it home on his shoulder. To cook the kangaroo the Mimi gathered wood, stones and strips of bark and made a big fire. Then he broke the joints of the kangaroo, tied them together and burnt the fur. The kangaroo was cut open and the intestines, heart, kidneys and fat were removed and cooked separately. Hot stones were put inside the kangaroo, and it was then buried in a deep ground oven and left to cook.[2] This story accounts for current Aboriginal hunting and cooking techniques.

The best of the contemporary painters of western Arnhem Land have a new strength and vitality. Each artist, depending on the subject being interpreted, offers his or her own different characterisation. Here, imaginative spirit images vary individually and are very strong. Many create an emotional impact with their frightening forceful faces, huge eyes or oddly placed limbs.

DECLAN APUATIMI

Group or Language: TIWI
Area: BATHURST ISLAND

Tiwi burial ceremonies are famous for the huge ironwood burial poles which are carved from whole trees, then painted with geometric patterns. These, along with sheets of similarly decorated bark sewn into two sided baskets, are placed around the grave site.

This painting is a typical Tiwi design. Circles can represent arm-bands worn in funeral ceremonies. In this case the precise meaning was not given by the artist.

TIWI DESIGNS c. 1974
Australian National Gallery (94 x 59.5cm)

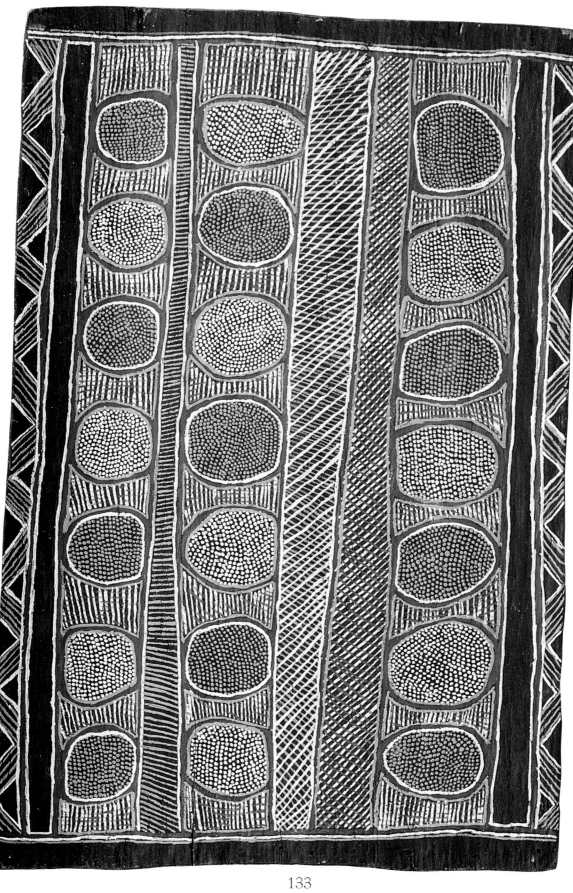

NELLIE ULUNGURU

Group or Language: TIWI
Area: PARU, MELVILLE ISLAND

The design represents coral reefs which lie just off the coast. Broken coral litters the beach near Paru, and each painting reflects the structural pattern of a particular type of coral.

CORAL 1974
Australian National Gallery (51 x 41.8cm)

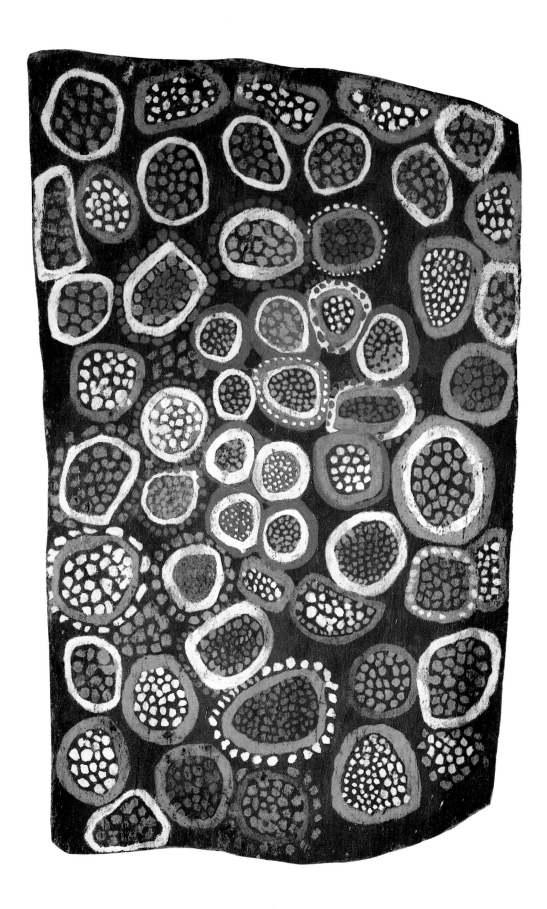

Bob Balirrbalirr Dirdi

Group or Language: GUNWINGGU
Area: OENPELLI

The painting depicts the site where a creation ancestor changed form and made himself into rock during the creation era. These body designs can be seen today on the rock in the Alligator River.

The fine patterned lines are part of the torso of the kangaroo figure, including hands or paws, and hip bones. The physical details are so finely painted that they merge into the total pattern.

METAMORPHOSED ANCESTOR SPIRIT 1969
Private Collection (61 x 39cm)

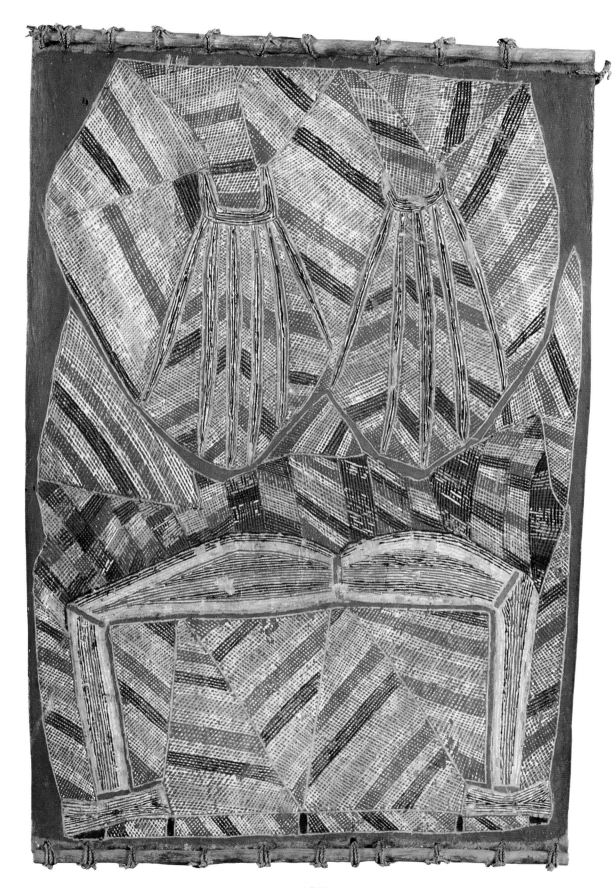

137

BARGUDUBU

Group or Language: GUNWINGGU
Area: WESTERN ARNHEM LAND

The Rainbow Serpent is a universally important creator spirit among Arnhem Land Aborigines. It is believed to have many different manifestations and is known by various names.

To the Gunwinggu people, Ngalyod is the creator from whom they are descended. She/he is particularly associated with sacred ceremonies, the cycle of seasons and the regeneration of all living things.

If tribal laws are broken Ngalyod takes revenge by sending drought, cyclones and floods.

RAINBOW SERPENT 1970s

Private Collection (105 x 75cm)

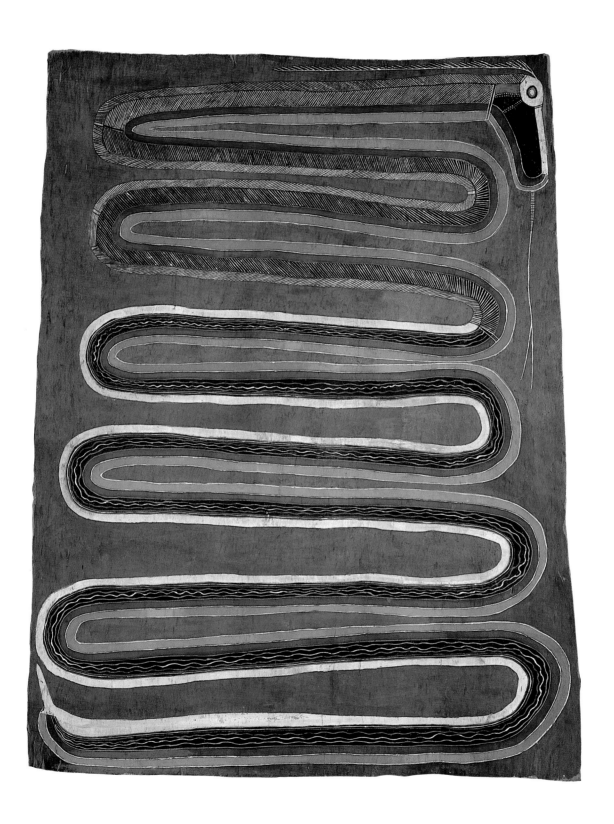

DJANBARDI

Group or Language: REMBARRNGA
Area: MANINGRIDA

This painting of a goanna by Djanbardi is one of the series of designs used to denote the sacred animals of Rembarrnga stony escarpment country west and inland from Maningrida.

GOANNA 1979

Courtesy Hogarth Galleries (112cm x 37cm)

GEORGE DJAYGURRNGA

Group or Language: GUNWINGGU
Area: MANINGRIDA

The Lightning Spirit ancestors are often shown as male, however this image is a maternal figure.

The Lightning Spirit is active in the wet season, causing thunder and lightning. The bands from the figure's head to the knees and feet represent the lightning bolts.

The tradition of painting the Lightning Spirit in this form is ancient. The cave paintings of the Kakadu area include a similar image at Nourlangie rock. This painting has been maintained by the site custodians and was last re-painted in 1963. The fear and reverence accorded the Lightning Spirit remains an important aspect of western Arnhem Land belief.

LIGHTNING SPIRIT 1977

Private Collection (72 x 40cm)

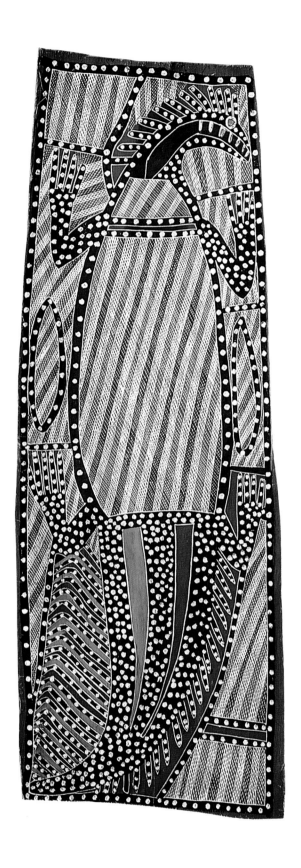

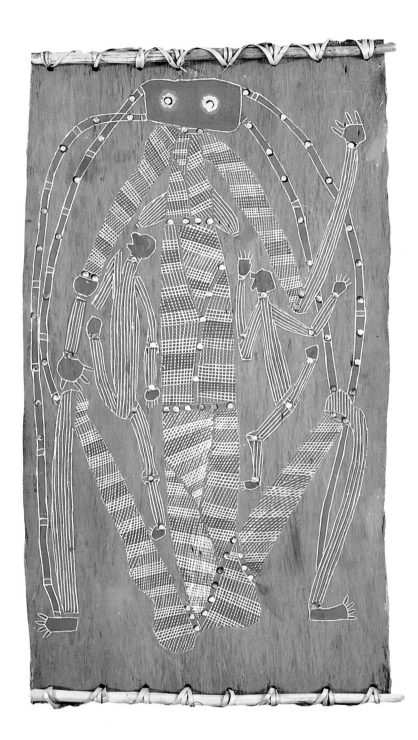

141

MARALWANGA

Group or Language: GUNWINGGU
Area: MANINGRIDA

This creation ancestor appears in various manifestations in western Arnhem Land. As a serpent, she tunnels underground using a bony protuberance from her neck as an aid.

In this painting the artist shows the serpent in a classic position, without additional mythological visual detail. The beautiful deep purple ochre colours are unique to Maralwanga's own country. These and his fine technique make him a particularly distinctive artist.

NGALYOD, RAINBOW SERPENT 1976

Private Collection (126 x 51cm)

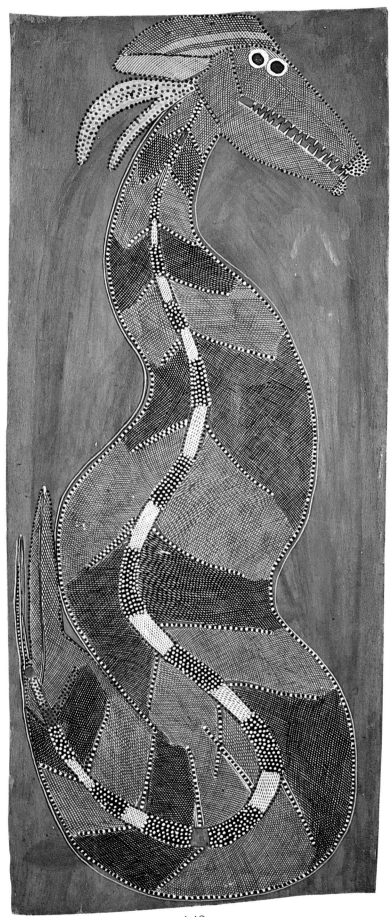

143

MARALWANGA

Group or Language: GUNWINGGU
Area: MANINGRIDA

This painting of two stingrays is a most outstanding work by the artist who is known for his immensely fine and painstaking patterning as well as draughtsmanship.

The stingrays are creatures of totemic importance in the artist's own country, west of Maningrida.

NAWILAH DREAMING 1980

Courtesy Hogarth Galleries (125 x 50cm)

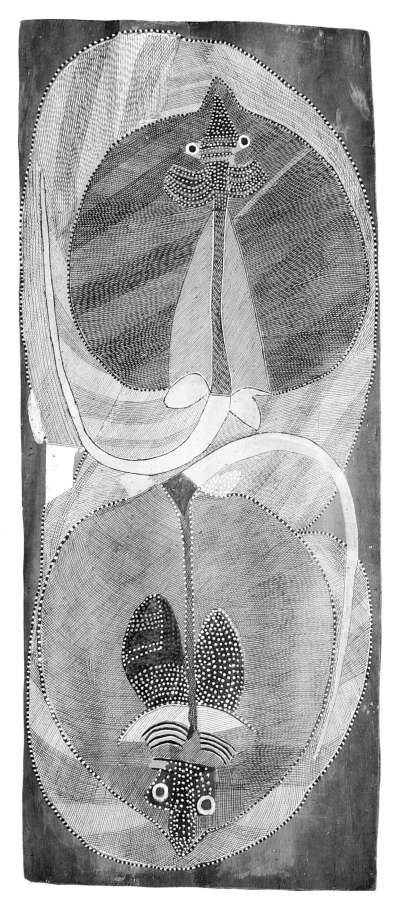

Yuwun Yuwun Marruwarr

Group or Language: GUNWINGGU
Area: OENPELLI

This is a classic image of a plains kangaroo painted by one of the great generation of Oenpelli artists of the sixties.

The killing and handling of large game must be undertaken according to prescribed ritual procedures.

As hunter and meat provider the artist is always an acute observer of nature and animals are accurately drawn, complete with some internal organs which may have ritual meaning.

Artists generally paint their own animal ancestral beings, so that even simple images of individual animals have religious meaning to the artist.

KOLOBAR KANGAROO 1971

Private Collection (69 x 38cm)

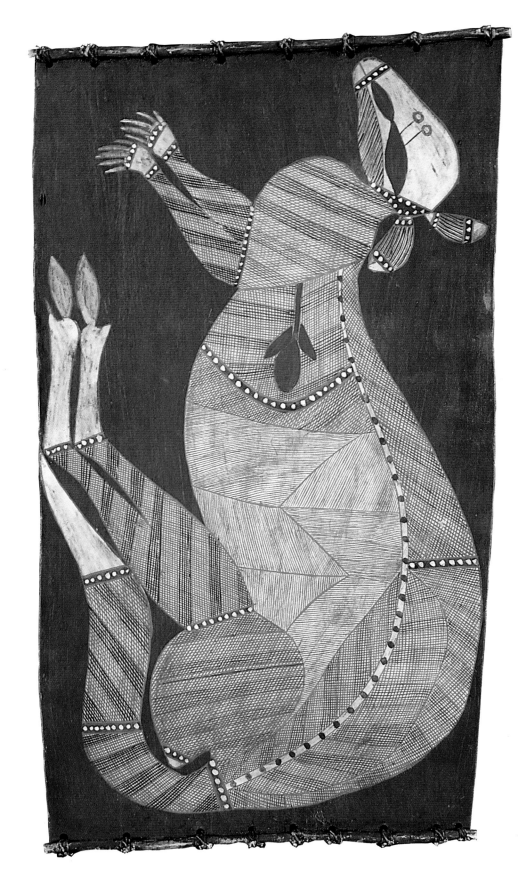

Peter Nganjmirra

Group or Language: GUNWINGGU
Area: OENPELLI

The painting is about the activities of mimi spirits. These are described as thin frail spirits easily blown about by the wind. They live in the caves and crevices of the rocky western Arnhem Land escarpment area and emerge nocturnally to harass people, although they are not usually evil, merely mischievous.

Mimi paintings on rock are ancient — 20 000 years old. They are generally shown in everyday activities that parallel Aboriginal life and are thought to have taught the first people many hunting and food gathering skills.

MIMI & NAMORODO SPIRITS 1982
Courtesy Hogarth Galleries (68 x 39cm)

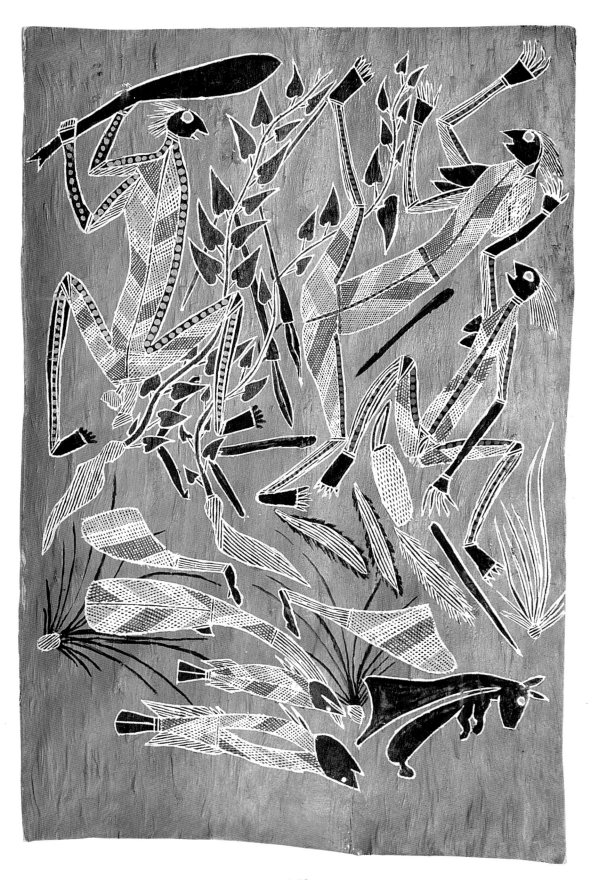

BOBBY NGANJMIRRA

Group or Language: GUNWINGGU
Area: OENPELLI

Luma Luma was a ferocious ancestral giant revered throughout western Arnhem Land. He came from the Crocodile Islands to the mainland and is associated with the Rainbow Serpent hence his snake-like penis.

After incidents of gluttony and predatory sexual exploits he was finally speared to death by the people. Before he died he passed on many details of ritual and lore which are still observed.

LUMA LUMA THE GIANT 1988
Courtesy Caz Gallery (149 x 55cm)

ROBIN NGANJMIRRA

Tribe: GUNWINGGU
Area: OENPELLI

In this painting the artist has depicted a large 'dreaming' crocodile in the 'x-ray' style of Oenpelli, in which the inside as well as the outside structure is shown. Several mimi spirits are dancing around. Two traditional woven dilly bags are shown, two fishing spears, a shovel nose spear for killing animals, and a woomera. The water lily bulb and leaves indicate the presence of water.

In western Arnhem Land it is believed that the gap in the Liverpool Ranges, about 150 miles from Oenpelli, was caused by the first crocodile, a land creature, carving his way through to reach salt water.

CROCODILE DREAMING 1988
Courtesy Caz Gallery (149 x 61cm)

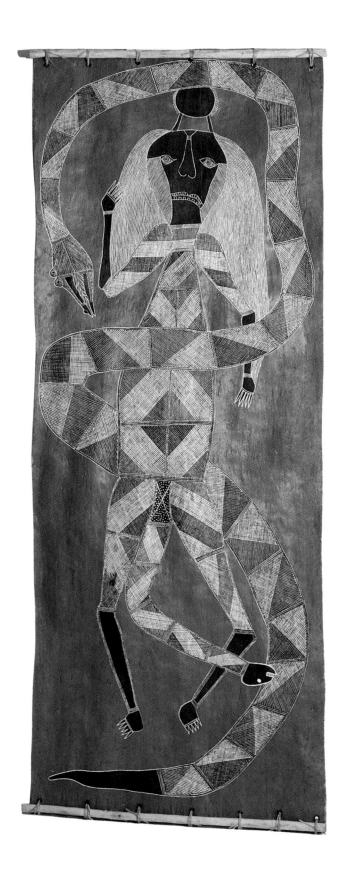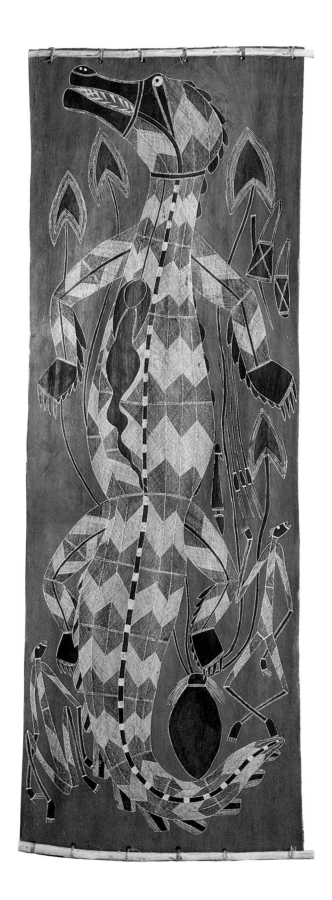

Nguleingulei

Group or Language; GUNWINGGU
Area: OENPELLI

Spirit being with woven dilly bag and other objects. The treatment of genitalia is unusual. No details of the meanings were offered by the artist.

The style of this painting links the work with the cave paintings of western Arnhem Land. The artist spent most of his life in the bush. He worked for some time in a timber camp and as a crocodile shooter but has retained his beliefs about the spirits of the land throughout his life.

TWO MIMIS 1977
Courtesy Hogarth Galleries (58 x 64 cm)

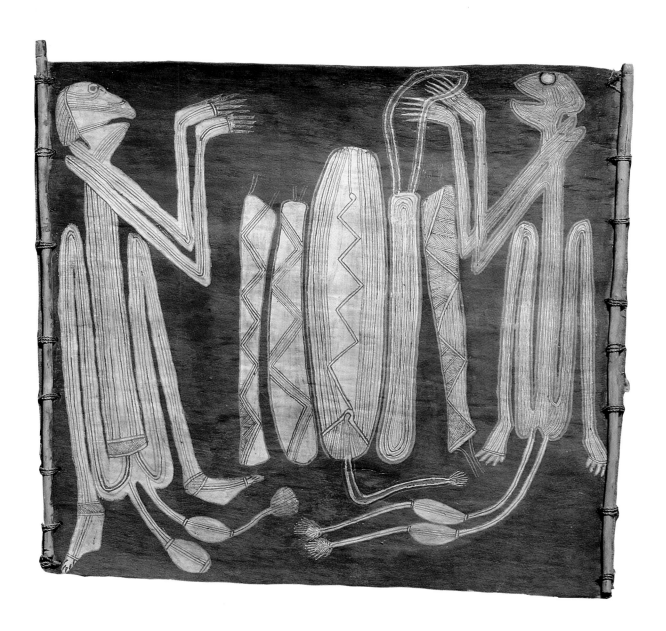

BRUCE NABEGEYO

Group or Language; GUNWINGGU
Area: OENPELLI

The Rainbow Serpent is a central ancestral spirit and is both revered and feared. The Rainbow Serpent is closely connected to the advent of the wet season and therefore the renewal of new life and rebirth of the species.

In this painting the serpent appears with a python and mimi spirits, one of which has had an arm bitten off by crocodiles.

Several crocodiles are shown as well as flying foxes and a boomerang used to knock them down from trees. A dilly bag, yams and a leech offer further clues to the context. The mimis have been gathering yams, and, when they went into the leech infested water to get other foods like water lily corns, the crocodiles attacked.

RAINBOW SERPENT, MIMIS AND BUSH CREATURES 1987
Courtesy Caz Gallery (146 x 47 cm)

THOMPSON YULIDJIRRI

Group or Language: GUNWINGGU
Area: OENPELLI

The sinuously elegant lines of this painting of a brolga express the grace of these remarkable tall grey and pink birds which are common in Arnhem Land. The brolga's mating dance is a strutting ballet imitated in dance by many different northern Aboriginal groups in both public and sacred ceremonies.

BROLGA AND BUSH TUCKER 1988
Courtesy Caz Gallery (151 x 63cm)

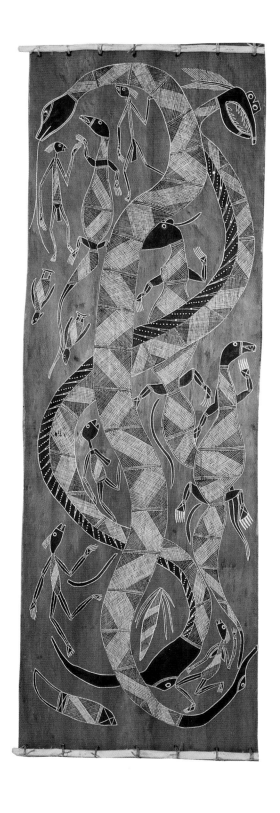

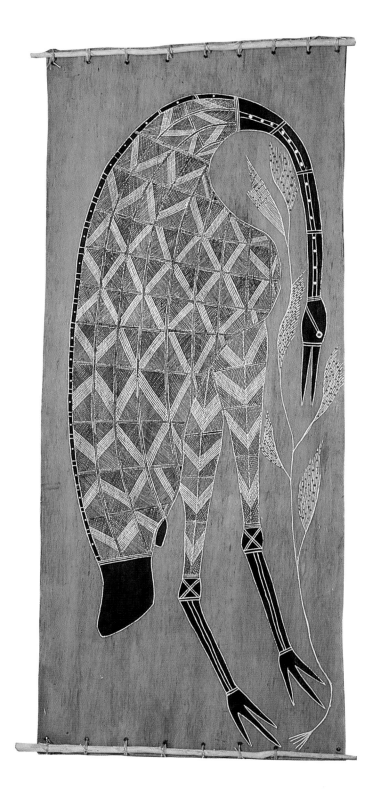

George Milpurrurru

Group or Language: GANALBINGU
Area: RAMINGINING

The artist frequently paints different versions of the flying fox story. These small creatures are numerous in Arnhem Land and hang from the branches of large forest trees feeding on the flowers and their nectar. Their droppings fall beneath the tree and are shown in the painting as dots amongst the fallen flower patterns.

Depending on their diet flying foxes taste as aromatic as the fruits and flowers on which they feed and are a favourite Aboriginal food.

WARRNYU FLYING FOXES
The Power Gallery of Contemporary Art (Acquired 1984)

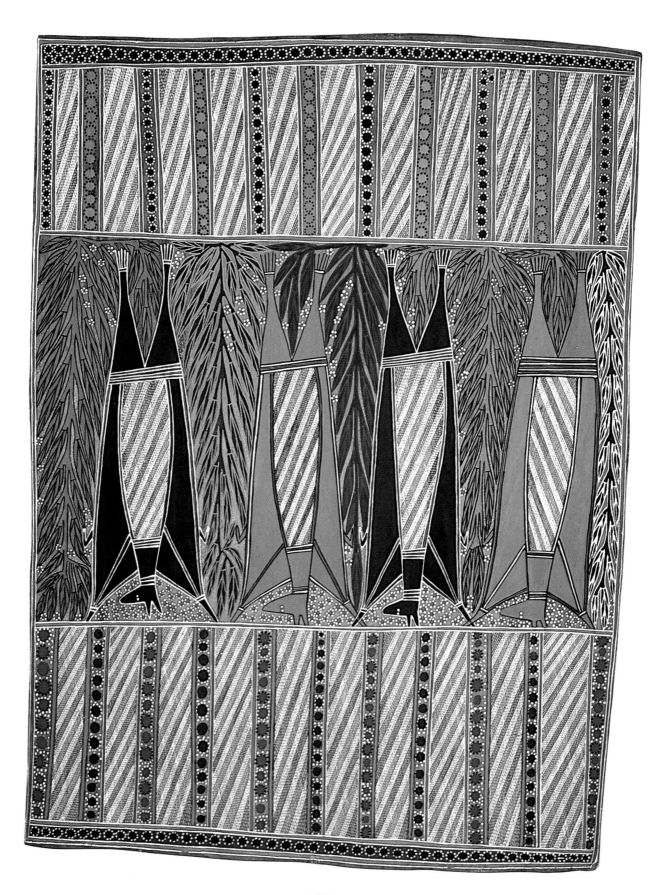

GEORGE MILPURRURRU

Group or Language: GANALBINGU
Area: RAMINGINING

The artist is Ganalbingu ceremonial leader and head of his own outstation at Walkabimirri, a community between Ramingining and Maningrida.

His paintings are masterworks of precision and draughtsmanship. His early paintings of the 1970s depicted many visual details and characters from the ancestral dreaming events of his own country. Recent works are larger and simpler in scope concentrating on one element of the landscape or story being told. This work meshes a number of totemic snakes to form a strong design which symbolically represents a wider story.

SNAKES AT THE WATERHOLE 1983

Private Collection (123 x 63cm)

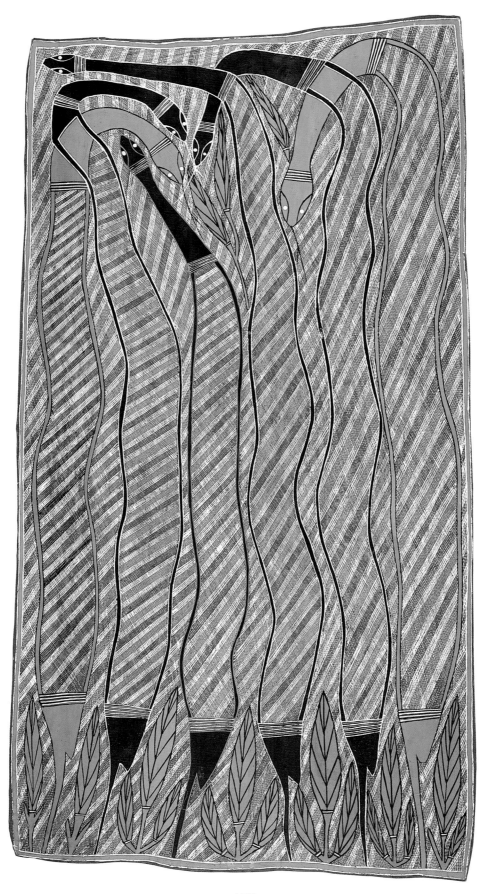

Johnny Bulun Bulun

Group or Language: GANALBINGU
Area: GAMEDI

The painting depicts the final stage of a mortuary ceremony when the stripped bones of the deceased are broken and placed into a hollow log bone-coffin as depicted in the centre of the painting. At the top of the hollow log one of the deceased's male relatives is placing the skull into the bone-pole. The rest of the bones are shown in the top right hand corner of the painting and on either side are the mourners.

MORTUARY STORY

Northern Territory Museum of Arts and Sciences (Acquired 1982) (111 x 97.1cm)

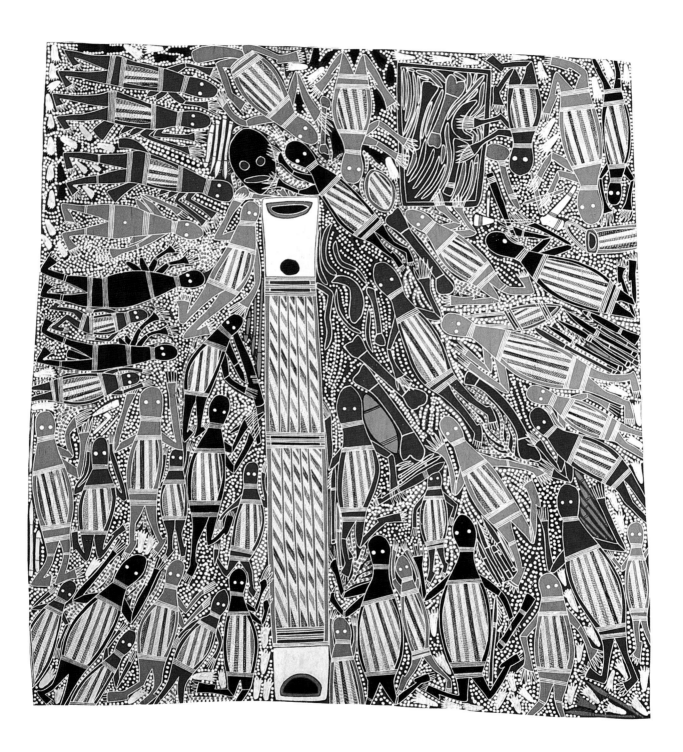

TONY DANYULA

Group or Language: LIYAGAWUMIRR
Area: RAMINGINING

Mud crabs are delicious food gathered from coastal areas near mangroves. The origin of their use lies in the Djankawu ancestral journeys. In an area between Howard Island and the mainland, they travelled along making waterholes until they were hungry. Then they entered the mangroves at a site called Gariyak, and, using their digging sticks, extracted Nyoka, mud crabs which they cooked and ate.

NYOKA MUD CRABS

Power Gallery of Contemporary Art (Acquired 1984)

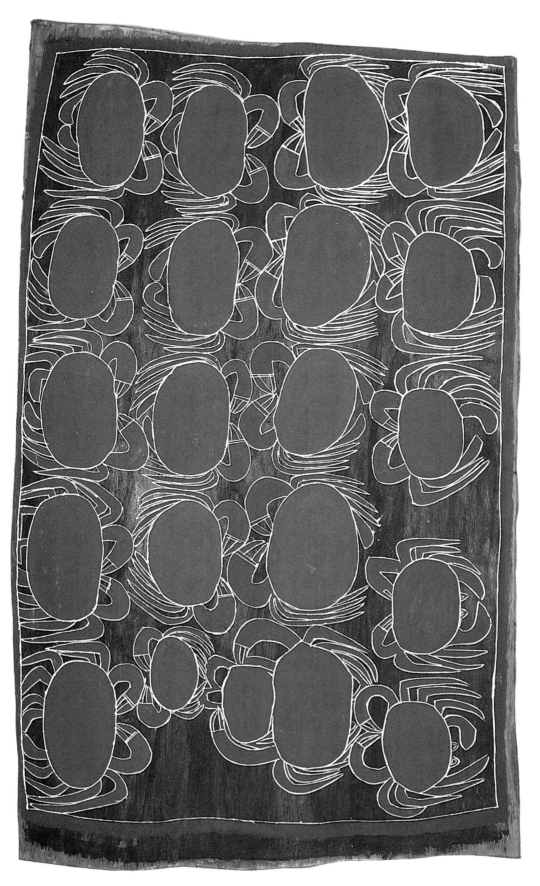

CLANCY GIRRPIRRKLIL

Group or Language: DARBI
Area: RAMINGINING,

The Dhudingurr snakes are special to the Darbi Language Group of central Arnhem Land of which there is only one painter still living. It is an unusual composition simultaneously depicting the dormant water snake beneath its waterhole and a group of snakes rising to the sky as rainbow serpents signified by lightning during the wet season.

DHUDINGURR WATER PYTHONS
Private Collection (Acquired 1983) (73 x 37cm)

DON GUNDINGA

Group or Language: WURRKIGANYDJARR
Area: RAMINGINING

The painting depicts a group of totemic animals at a site called Walkumbimirri in the artist's country during an incident in one of the creation stories which tells of the great honey ancestor first finding bush honey. Some of the characters involved are bandicoot, geckos, goannas, and in the lower right hand corner, an ancestral woman who changed into a rock.

TOTEMIC ANIMALS
Power Gallery of Contemporary Art (Acquired 1978)

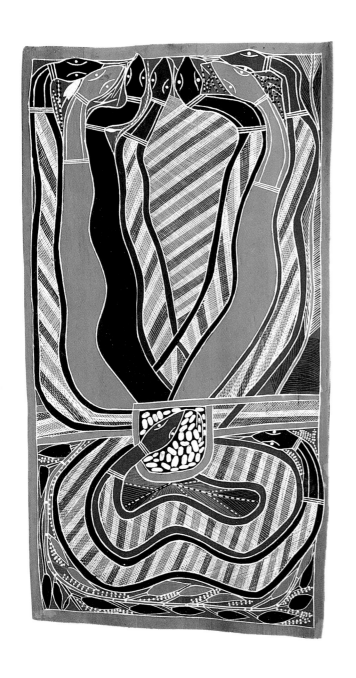 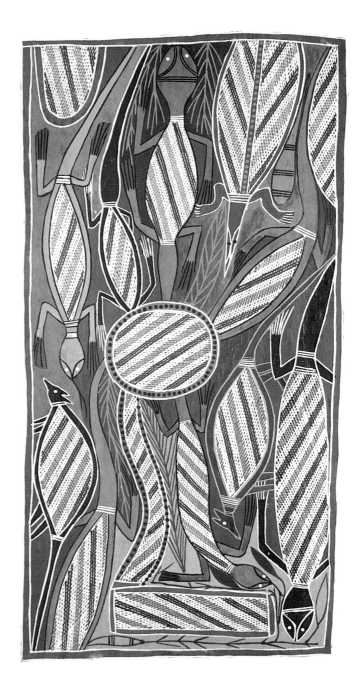

GORRORPORAL

Group or Language: GANALBINGU
Area: MANINGRIDA

Wiara Spirits of the Djarbi tribe guard the sacred waterhole Balinga. The Balinga waterhole is south of Ramingining in central Arnhem Land. It has a great variety of wildlife, especially that which the artist has depicted . . . Kulkarngara, the catfish; Watara, the black rockfish; Gudurpula, the diving bird and Gurmala, the egret.

BALINGA WATERHOLE 1982
Courtesy Hogarth Galleries

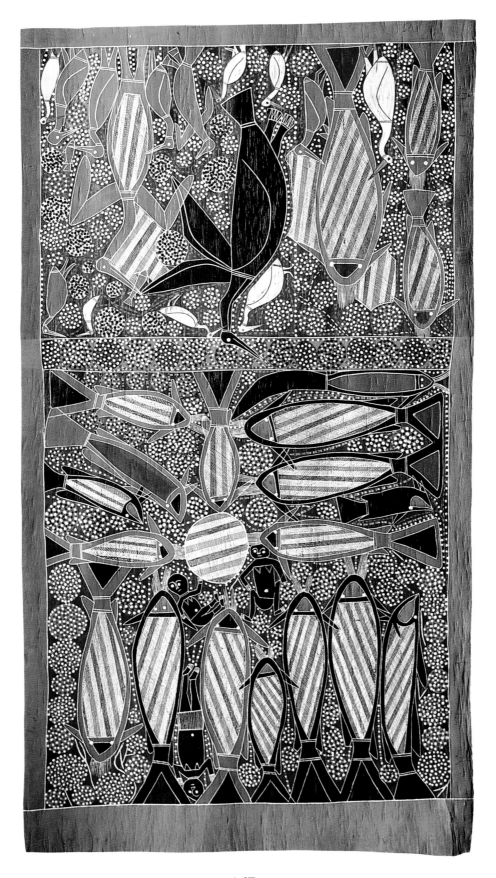

167

David Malangi

Group or Language: MANHARRNGU
Area: RAMINGINING

David Malangi has illustrated an incident from the creation journeys of the Djankawu sisters, the major ancestral myth of creation which extends from the east coast of Arnhem Land to Ramingining.

During the Djankawu ceremonies the songs reveal that the two sisters came to the open grassy plains between Ramingining and the sea, and there they saw a group of bustards sunning themselves near a waterhole and named them 'Buwata'.

The songs are still sung in sacred Djankawu ceremonies and the bustards can be seen at this site beneath the dhangi tree depicted. In the branches sits a white cockatoo.

BUWATA BUSTARD

The Power Gallery of Contemporary Art (Acquired 1984) (72 x 42cm)

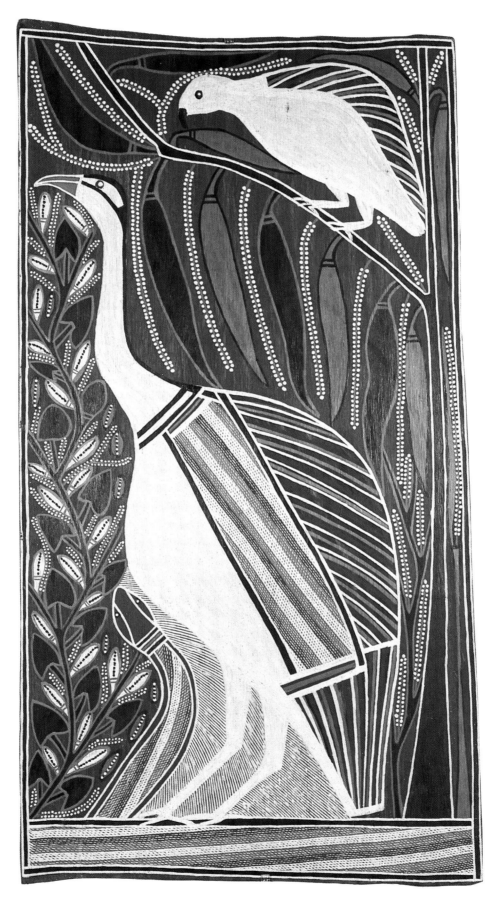

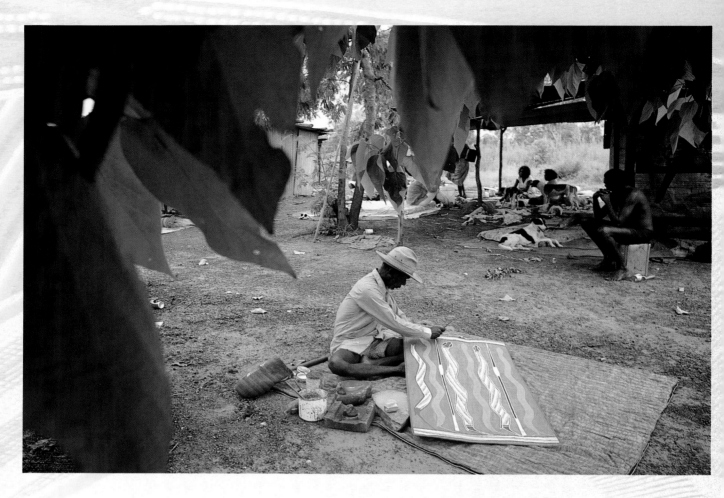

David Malangi paints in his family compound, the tranquil outstation Yathalamara near Ramingining, central Arnhem Land.
Artists' materials: orchid stem, human hair brushes and ground ochre stones.

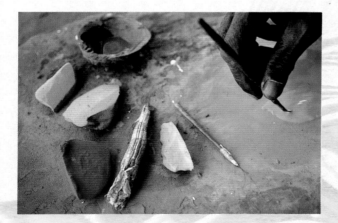

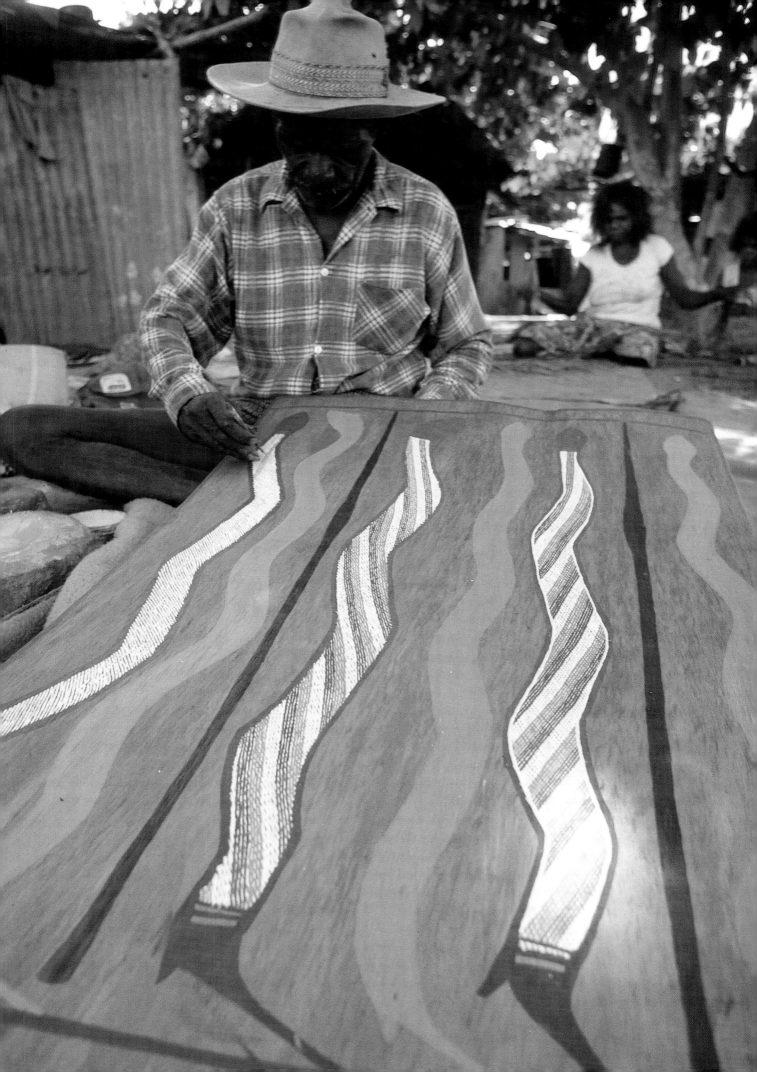

WANIMALIL

Group or Language: GANALBINGU
Area: MULGURRAM

In this spectacular painting the artist has incorporated all the insect, animals and plant totems which belong to his mother's clan. He has woven an intricate design including caterpillars, plant foods, geckos and leaves of the stringy-bark tree.

MOTHER'S CLAN TOTEMS

Northern Territory Museum of Arts and Sciences (Acquired 1983) (127 x 77cm)

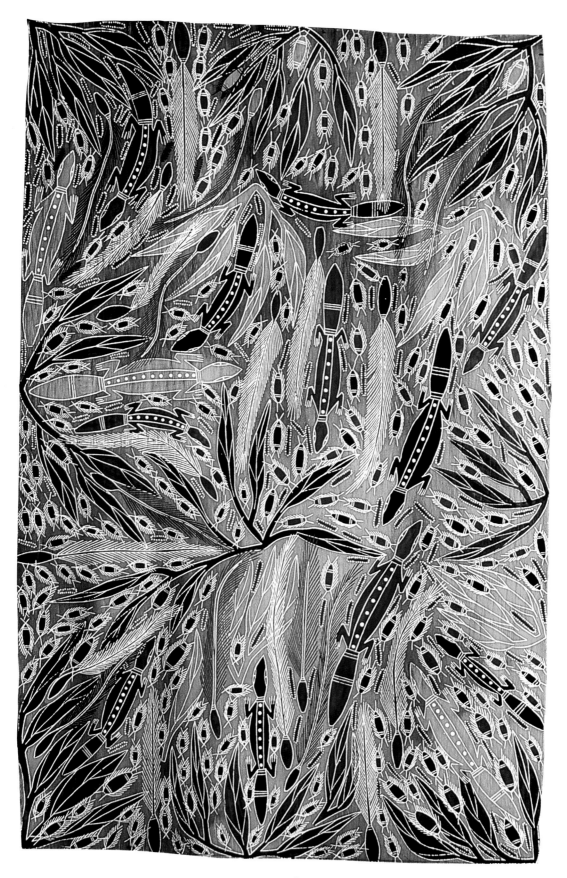

WULULU

Group or Language: GUPAPUYNGU
Area: RAMINGINING

The diamond pattern in this painting is the Yirritja symbol of honey. The design was given to the Gupapuyngu by a great Ancestral Being of the Dreaming.

In this painting the honey cells are full. The central object is a sacred depiction of a ceremonial object, which in its broader interpretation also symbolises the native beehive in the hollow tree.

HONEY DESIGN 1980s

Department of Aboriginal Affairs

174

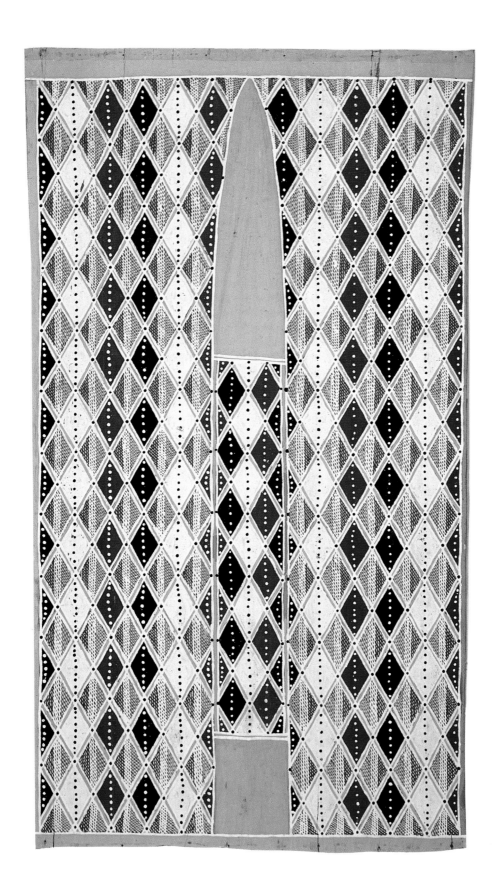

175

DAYPURRYUN

Group or Language: LIAGAWUMIRR
Area: ELCHO ISLAND

The most important creation ancestors of the Dhuwa peoples of north eastern Arnhem Land are the Djankawu. The Djankawu, a man and two sisters, came by canoe from the mythical island of Baralku, home of the morning star. They arrived on the coast of Yelangbara (Port Bradshaw) and proceeded to travel throughout the land, to Gali'winku (Elcho Island) and then back to Ramingining. Along their route they created sacred waterholes, gave birth to whole clans and gave languages, custom and song.

This painting is a sacred rendition of objects and land features of a Djankawu site on Gali'winku.

DJANKAWU STORY 1980
Courtesy Hogarth Galleries (125cm x 38cm)

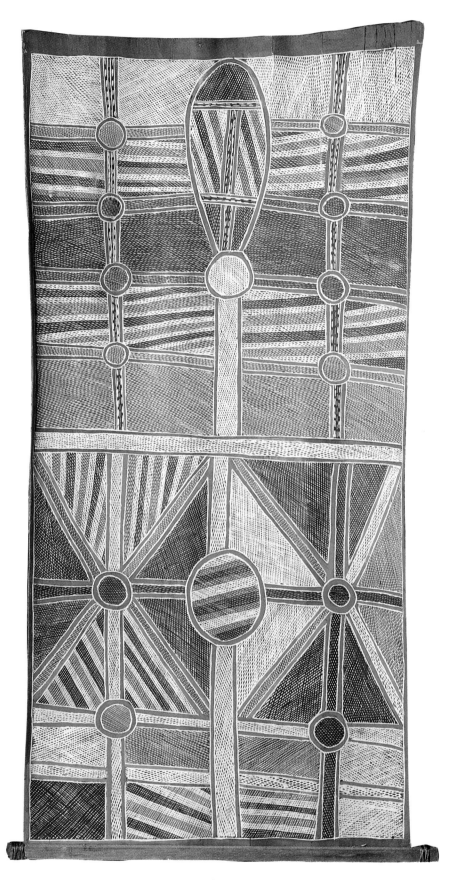

177

DJIWIDA

Group or Language:
Area: MILINGIMBI

This image represents the sacred waterhole where the two creation sisters known as the Wawilak were swallowed by the great python, or rainbow serpent.

These two sisters had journeyed far, creating features of the landscape. One was about to give birth so they made camp by the waterhole. Their string bags and pandanus dilly bags were full of small game.

When one sister inadvertently 'polluted' the water, the giant snake rose to the sky, flashed lightning and devoured the sisters. Although the sisters are not shown in the painting, the animals, snake, waterhole and circular plan of the composition are common to many Wawilak paintings.

THE WAWILAK SISTERS 1980
Courtesy Hogarth Galleries

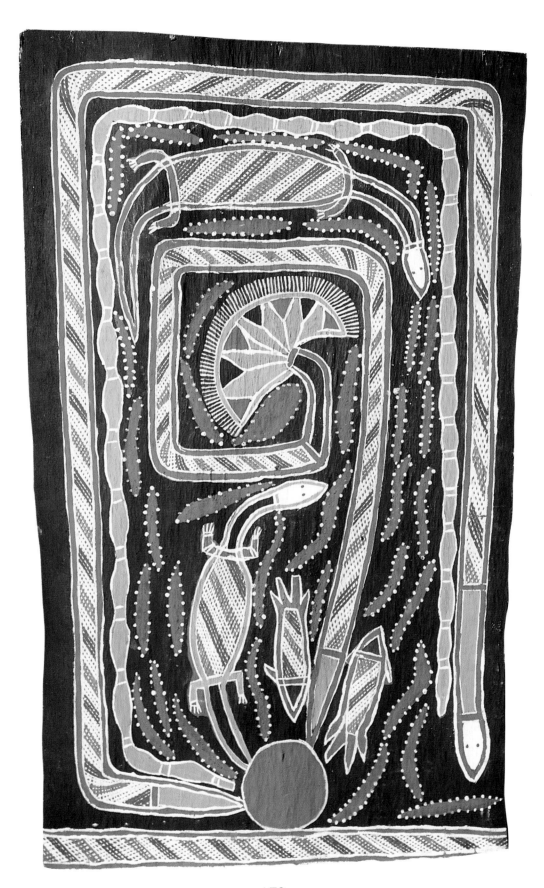

179

DOROTHY DJUKULUL

Group or Language: GANALBINGU
Area: RAMINGINING

This painting represents an incident in the story of an important Ancestral Being who travelled along the coast of central Arnhem Land near the Glyde River. He was accompanied by his dog and at one point in the journey he entered a cave which was the home of nesting flying foxes. The white dots represent the mounds of their droppings on the cave floor.

WONGGAR DOG STORY
Northern Territory Museum of Arts and Sciences (Acquired 1979)

WALIKA GANAMBARR

Group or Language: NGAYMIL
Area: YIRRKALA

The Djankawu, creation ancestors of the Dhuwa people of north east Arnhem Land, came to the coast in their canoes by following the morning star. As they beached and came ashore they saw goanna tracks on the sandhills and djanda, a large black goanna.

Djanda is now a sacred totem for the people.

DJANDA, GOANNAS 1980
Courtesy Hogarth Galleries

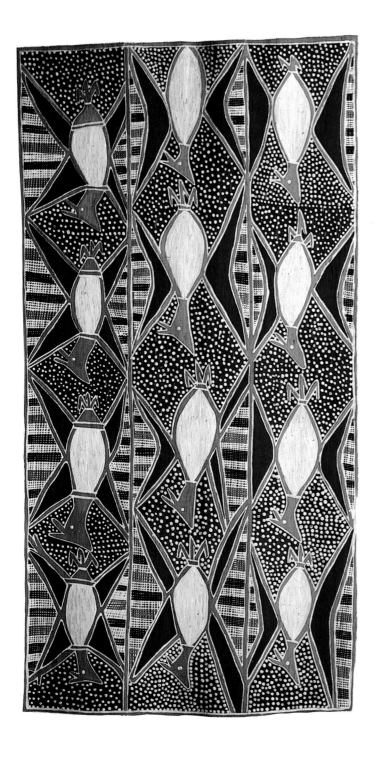
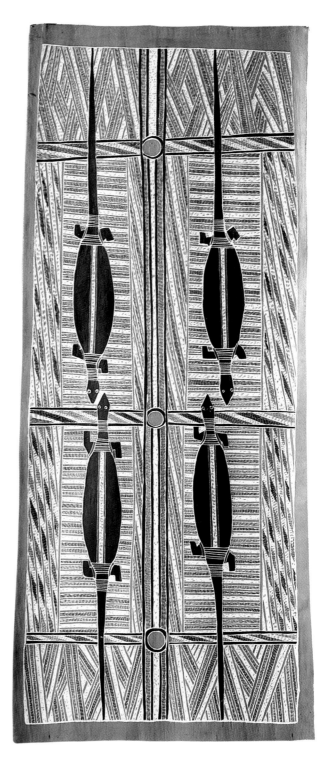

MANDJUWI

Group or Language: GALPU
Area: ELCHO ISLAND

The animals in this painting are Wurrkadi. They can be seen entering and leaving the small holes where they live. The lines with the white dots are their tracks in the sand. The white cross hatching surrounding each Wurrkadi is Gulaka yam which they have been eating and the remains are around them on the ground.

The yellow, red and black cross-hatching represents the grooves on the ground made by the rain or sea water. The two lines with white dots at the top and bottom of the bark represent Gundirr edible clay and are really people from the past.

The Wurrkadi in fact symbolise Aboriginal people performing ceremonies at the time of initiation and funerals.

WURRKADI 1980

Courtesy Hogarth Galleries (130 x 55cm)

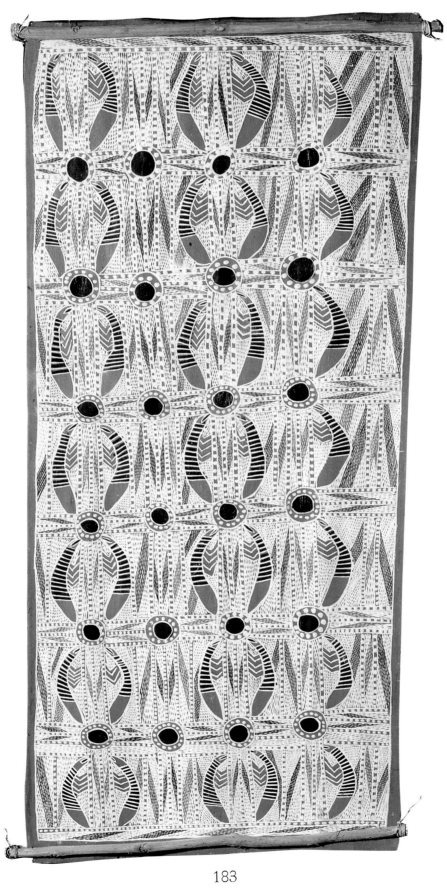

183

MAWALAN MARIKA

Group or Language: RIRATJINGU
Area: YIRRKALA

This painting records the central event of the first phase of creative actions of the Djankawu ancestors at Yelangbara. After arriving by canoe the Djankawu brother and two sisters made special features of the landscape particularly waterholes and rock formations.

The brother carried a sacred pole or emblem with feathered string attached. This, the mawalan or djuta, is the namesake of the artist and his grandfather, and is the central motif of the painting. The small bustards which were seen by the Djankawu at Yelangbara are shown against the sacred Riratjingu design for Yelangbara itself. The fan-like images on either side represent a series of sacred cabbage tree palms which now grow at the sacred sites associated with the Djankawu, not only at Yelangbara but across eastern Arnhem Land.

DJANKAWU SACRED EMBLEM 1988
Private Collection (129 x 63cm)

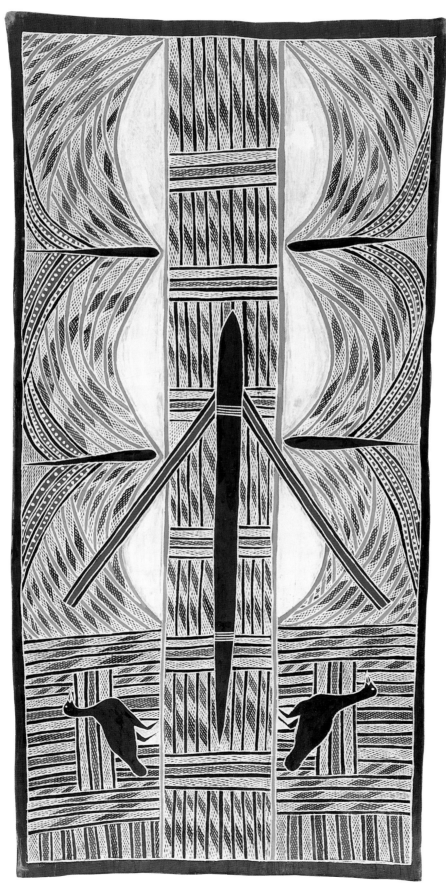

185

NARRITJIN

Group or Language: MANGGALILI
Area: YIRRKALA/DJARRAKPI

The painting represents the creation story of two fishermen Yikuyanga (Jikawan) and Munumiya who were sitting under a native cashew tree at Djarrakpi in Manggalili country. Guwak, the koel cuckoo, who was sitting on top of the tree, told the men to go out fishing — so they went out in their bark canoe.

Far out to sea the canoe was overturned by a huge wave. One of the men swam most of the way to Baniyala where he died and his body turned to stone. The other man's body was thrown up by the tide on the beach at Djarrakpi. His body was covered with designs made by the incoming tide as it washed over him. The designs became the clan designs used by the Manggalili clan. The canoe was also tossed up by the tide at Djarrakpi where it changed into a number of rocks on the beach.

A funeral ceremony performed for Yikuyanga and Munumiya was the first Manggalili funeral and set the form to be followed thereafter.

FISH TRAP 1980
Courtesy Hogarth Galleries (195 x 80cm)

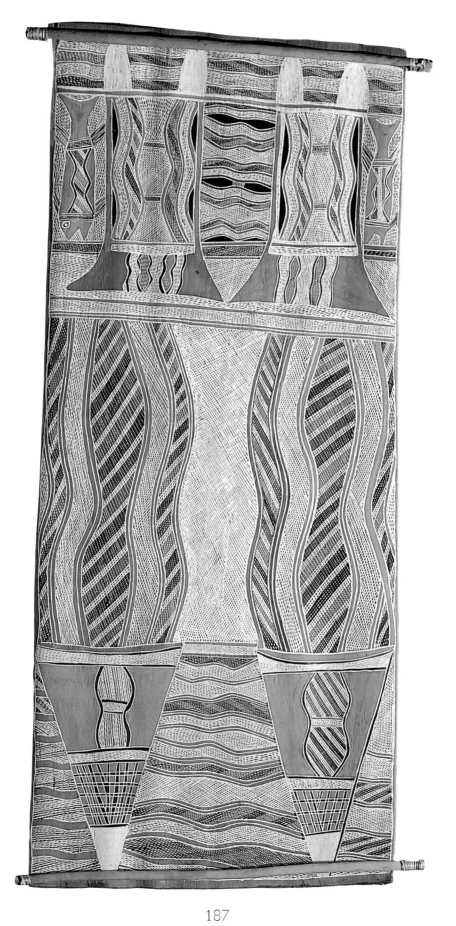

NARRITJIN AND SON

Group or Language: MANGGALILI
Area: DJARRAKPI

The painting records in detail the substance of two linked creation stories of the Manggalili. The first is commonly called 'the Milky Way story' and records how two men Yikuyangu (Jikawann) and another, were fishing for rock cod. A storm approached so they began to paddle their canoe back to shore but as the seas rose their canoe was overturned and their paddles swept away.

Jikawann's friend was carried by the sea into the mangroves whereas the body of Jikawann was first attacked by two crocodiles, then swallowed by a large whale. Jikawann's friend conducted a ceremony in the mangroves about the mangrove root depicted in the painting as a totemic sacred object with two points. The crocodiles and whale came near to hear the singing.

All the creatures in this creation story then were drawn up into the sky where they are now seen as part of the Milky Way. The painting also features a fishing spear and storm cloud design.

The central curved panel in which Jikawann and the two crocodiles appear contains the pattern of the Milky Way. The panel shape itself represents the whale which is also synonymous with a sacred Manggalili fish trap. This trap was once two sacred dreamtime baskets laced together with reeds. In another major ceremonial creation story, having served their purpose of teaching the people how to catch fish, the sacred fish-trap baskets changed into a whale.[2]

FISH TRAP AND MILKY WAY

The Australian Museum (Acquired 1978) (198 x 65cm)

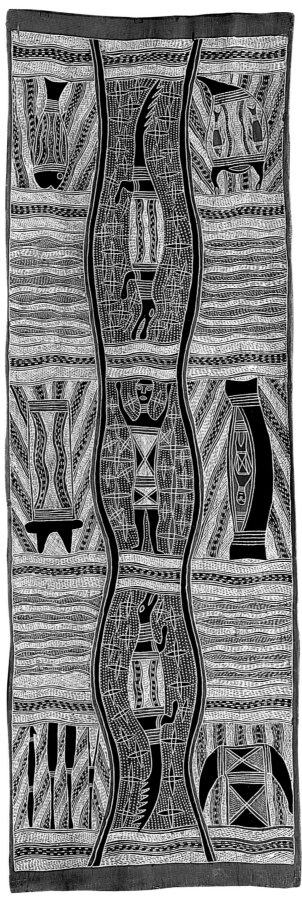

189

ACKNOWLEDGEMENTS

Secretarial Assistants: Carmel Pepperell, Meredith Aveling.

I also wish to thank the following people for assistance throughout the preparation of this book.

John Mundine of Ramingining Arts and Crafts, Diane Moon of Maningrida, Jan Gaynor of Aboriginal Artists Agency, Wally Caruana of The Australian National Gallery. I am indebted in particular to the individual galleries listed in the photographic credits for their kind assistance in allowing important paintings from their collections to be photographed for this book. Without this record such paintings would have remained in private hands and are seen by very few. In particular Mark Lennard of the Centre for Aboriginal Artists at Alice Springs selected and documented the paintings specifically for this publication. Daphne Williams of Papunya Tula, Alice Springs assisted greatly in providing stories from the artists whose works have been put forward by Gallery Gabrielle Pizzi, and Rangi Skenner from Caz Gallery and Kerry Steinberg from Hogarth are friends whose assistance was invaluable as well. I would also like to thank the Australian Stockman's Hall of Fame for assistance with the production of Bush Banana Dreaming, page 97.

PHOTOGRAPHIC CREDITS

Landscape and Portraits

I am very grateful for the generous contribution by *Claude Coirault* of the superb desert landscapes and portraits of artists, and to *Reg Morrison* for portraits of Arnhem Land artists at work, and the landscape photography in the top end.

Paintings

Thanks to the Centre for Aboriginal Artists, Alice Springs for photographs of the following paintings taken by Mark Lennard. Documentation on these works was collected by Mark Lennard and Ros Premont from the artists at the Centre for Aboriginal Artists, Alice Springs. Pages 49, 59, 63, 65, 67, 69, 71, 73, 75, 77, 79. 81, 83, 87, 89, 91, 95, 101, 105, 107, 111, 113, 115, 117, 119.

Thanks to Kerry Steinberg, Hogarth Galleries for access to the following paintings and their records in order to prepare the documentation. Photographs were taken by Reg Morrison. Pages 133, 141, 145 (left), 149, 153, 167, 177, 179, 181 (right), 183, 187.

Thanks to Jennifer Steele for the photographs of the following paintings. Pages 23, 25, 27, 29, 31, 33, 37, 41, 47, 57, 135, 137, 139.

Thanks to Gallery Gabrielle Pizzi for the following paintings, photographs taken by Henry Jolles. Documentation for these works was collected by Daphne Williams from the artists at Papunya Tula Artists. Pages 35, 39, 43, 45, 51, 53, 55, 61, 93, 103, 109.

Thanks to Rangi Skenner, Caz Gallery, Sydney for photographs of the following paintings taken by Adrian Hall. The basis of the documentation on these works was provided by Caz Gallery from notes prepared by Dorothy Bennett, Darwin. Pages 151, 155.

Thanks to Margie West of Northern Territory Museum of Arts and Sciences for documentation and photographs taken by Reg Morrison of the following paintings. Pages 161, 173, 181 (left).

Thanks to Kate Khan of The Australian Museum for documentaion and photographs taken by Reg Morrison, of the following painting. Page 189.

Additional photographs were taken by Per Ericson – pages 159, 185; Michael Riley – pages 157, 163, 165 (right), 169 [Collection Power Gallery of Contemporary Art]; Claude Coirault – page 97 and Reg Morrison – pages 155 (left) [Collection Art Gallery of South Australia], 165 (left).

NOTE ABOUT SPELLING

Standardisation of the spelling of Aboriginal language names, community names and even personal names is always difficult. In this volume, we have for the most part adopted the most common current spelling in use, although this varies. For example, some words in Papunya would commence with "Tj" whereas at Yuendemu it is simplified to "J", e.g. Tjungurrayi. Assistance in standardising spellings was provided by David Nash of the Australian Institute of Aboriginal Studies, but he should not be blamed for my own diversions from the common rules from time to time in this manuscript. Like the English language itself, as people became literate they adopted idosyncratic spelling versions themselves and where the artists spell their names a certain way, this has been retained.

INDEX OF PAINTERS

PAINTINGS OF THE WESTERN DESERT

BARK PAINTINGS
OF ARNHEM LAND

FOOTNOTES

Paintings of the Western Desert

1. The above story was related to the author by Peter Fannin, former teacher and art adviser at Papunya in the early 1970s. He collected many early stories of Water Dreamings from the Pintubi group who had begun to paint with Geoff Bardon in the early 1970s.
2. "Opera House Mural", Michael Nelson Tjakamarra with Ulli Beier, Art Monthly, June 1988.

Bark Paintings of Arnhem Land

1. A photograph showing bark paintings on display with other Oceanic art is reproduced in Sutton P., *Dreamings: The Art of Aboriginal Australia,* Viking, 1988, page154.
2. Story told by Peter Carroll in "Mimi from Western Arnhem Land" in P.J. Ucko (ed.), *Form in Indigenous Art,* Australian Institute of Aboriginal Studies, Canberra 1977.